IMAGES
of America

FORSYTH COUNTY
TWENTIETH-CENTURY CHANGES

D1319456

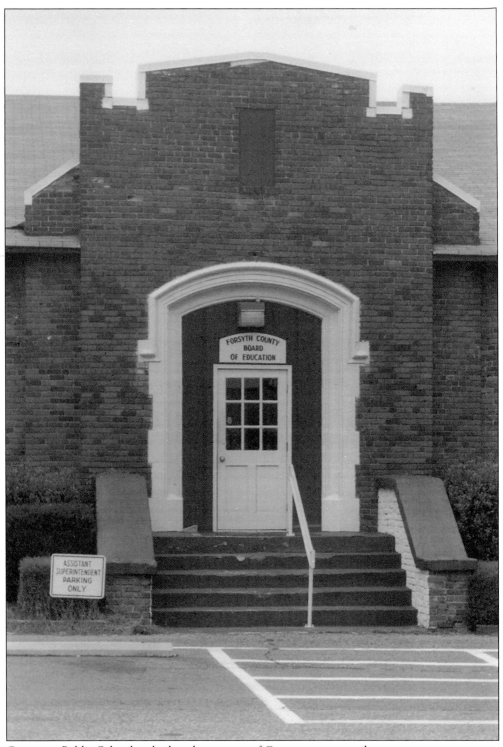

Cumming Public School embodies the essence of Cumming, past and present.

IMAGES
of America

FORSYTH COUNTY
TWENTIETH-CENTURY CHANGES

Annette Bramblett
Historical Society of Forsyth County, Inc.

ARCADIA
PUBLISHING

Published by Arcadia Publishing
Charleston, South Carolina

Printed in the United States of America

Library of Congress Catalog Card Number: 00-108021

For all general information contact Arcadia Publishing at:
Telephone 843-853-2070
Fax 843-853-0044
E-mail sales@arcadiapublishing.com
For customer service and orders:
Toll-Free 1-888-313-2665

Visit us on the Internet at www.arcadiapublishing.com

CONTENTS

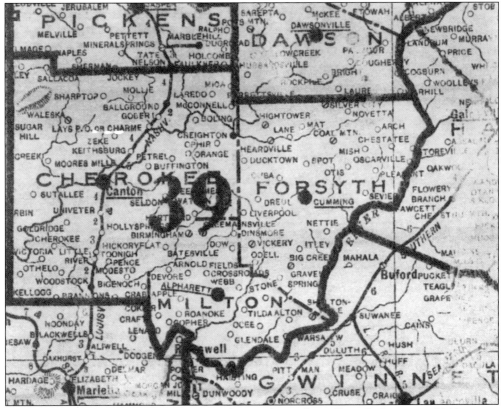

This map, issued by Georgia Department of Agriculture, shows Forsyth County in 1912.

ACKNOWLEDGMENTS

This book is made possible through the use of photographs from the Historical Society's Garland Bagley Collection, the Soil Conservation Service, the City of Cumming, the scrapbook of the late Maggie Harrison Worley, and numerous images from interested individuals, as well as from the private collection of the author.

Special appreciation is extended to my husband, Dr. Rupert Bramblett, for his patience, support, and helpful suggestions; to the officers of the Historical Society; to Linda Heard, Home Town Coordinator of the City of Cumming; and to Donna Parrish, Rupert Sexton, Nancy Swinson, Mary Sue Ridings, Vivian Tanner, and countless others who provided information, photographs, and support when needed.

INTRODUCTION

Forsyth County, created by an act of the Georgia Legislature in 1832 from lands previously owned by the Cherokee Indians, was settled within the following years, as were the other counties in North Georgia. The arduous tasks of clearing the land and erecting dwellings and outbuildings gave way to a routine agrarian lifestyle that changed little over the coming decades . . . until the 20th century, that is. Communities that had begun as agricultural settlements endured the abject poverty of the Depression. Then a rise in living standards was evidenced by mid-century.

Looking back to the early 1900s, today's citizens would doubtlessly recognize the mule and plow. But how many individuals would remember the conditions before the advent of soil stewardship? The eroded farmland unsuited for cotton crops? Streams overflowing their banks and wreaking destruction? Fewer still would have any thought that the planting of fescue—the grass that carpets pastures and roadsides—would spawn festivals in Cumming at mid-century.

Soil stewardship was not the only factor that propelled county residents from the hopeless situation of extreme poverty to reasonable living conditions by the 1950s. With the decline of cotton prices on the world market and the Depression virtually eliminating chances for progress, drastic measures had become imperative. Enter the chicken—the hot house chicken—and a new era in agriculture began. Add to it the switch in "crops" and the construction of a chicken plant in Cumming, and, by the late 1940s, a visible change in lifestyles could be witnessed. Citizens who had earlier fallen in love with the automobile could now own one—or a truck or a tractor or a threshing machine.

Improved living conditions ushered in an improvement in education as well. The schools, scattered about in the various settlements, changed from one-room, one-teacher wooden structures to brick edifices that housed multiple classrooms and offered an expanded curriculum.

The appearance of the area underwent another transformation, for the old wooden bridges—some covered—were being replaced by iron bridges, which would ultimately give way to the concrete spans of the latter part of the century. The streams and rivers were simultaneously undergoing improvement through erosion and flood control practices, which soon ended the destruction and inconvenience caused by swollen streams during the rainy seasons.

Through the years, the county has boasted distinguished leaders and productive individuals in all walks of life, but the entertainers are the ones best remembered. It has often been repeated that Will Rogers "never met a man he didn't like." The cowboy star and his saying are rooted in Forsyth County, the land of his Cherokee ancestors. Later another native, Junior Samples, found a dead fish in the road, spread a fish tale, and rode a wave of popularity that catapulted him via the *Hee Haw* television program into the living rooms of America.

For the past four decades, parade mania has swept the county. The Fourth of July brings out young and old alike to participate in or to view the unique spectacle of the Thomas-Mashburn Steam Engine Parade. What gives the parade its distinction? The extension of a tradition is

the key factor. From the days of farming, the steam engine has held special significance for Forsyth Countians. Thus, the noisy, antique engines continue to chug at a snail's pace around the Cumming Square every Independence Day.

As the steam engines have chugged their way through the streets of Cumming, the town has undergone a transition that renders it almost unrecognizable as the town of the 1970s. Traditionally, the changes in the county seat have been dictated by fire and rebuilding. Perhaps the most tragic fire of all was the one that took the beloved 1905 courthouse, which was set ablaze in 1973. The Williamsburg structure, which graces the square at present, was completed in 1978, after years of bond referendums and bickering over its style and location.

The remainder of the town has been transformed from a business district to a legal-centered complex with businesses, such as Parsons, which burned in 1982, moving to the outskirts. Constructed in 1974, city hall sits one block off the square adjacent to an impressive war memorial, but is to be replaced by a new building, based on the original plans for the 1905 courthouse, in the near future. Other modern structures include a county administration building, library, and a senior center, to name only a few.

The medical field has made great strides as well. When Georgia Baptist acquired the facility earlier known as the Forsyth County Hospital—erected in 1957 under the Hill-Burton Act—the medical group immediately began efforts to obtain a certificate of need to construct a larger building. And construct a grand, state-of-the-art facility Georgia Baptist did. Situated beside the Baptist Medical Center, the new doctors' building enables quality patient care to be offered with hometown convenience.

In addition to the grand new structures in Cumming, the town itself has undergone a "sprucing up" with the installation of traditional lampposts and iron railings. Likewise the city cemetery has been restored, improved, and given the name Cumming Historic Cemetery, for it is the resting place of the city's early citizens and community leaders.

Population changes have precipitated growing pains as well as brought affluence to the area. With an influx of new residents, Forsyth County at the close of the 20th century had reached a staggering 90,000+ population, with increases noted by the day! Of necessity, the call for added services requires the efforts of both the county and city governments; nevertheless, the need for preserving the county's heritage for posterity receives the attention of both entities as well. Heritage Village in the Cumming Fairgrounds and county parks in historic sections are but two areas in which the past is kept alive. In the near future, preservation efforts will pass to the younger generation. It behooves the old timers to pass on an understanding of and a love for the ways of yesteryear.

One

MATT AND DUCKTOWN COMMUNITIES

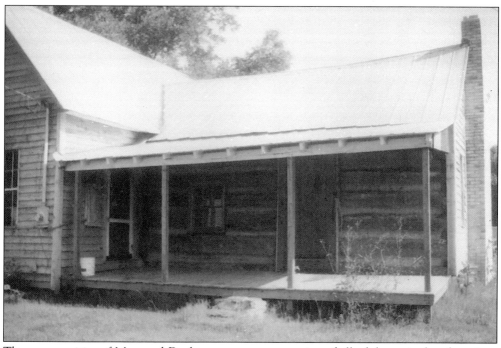

The communities of Matt and Ducktown are representative of all of the agricultural sections of Forsyth County. The agrarian lifestyle prevailed throughout the area. Pioneer settlers dwelt in rugged cabins, such as the one pictured above, which is the home of Reuben Worley and his descendants. The structure can still be seen across from the Zion Hill Baptist Church on Highway 369 in the Matt community.

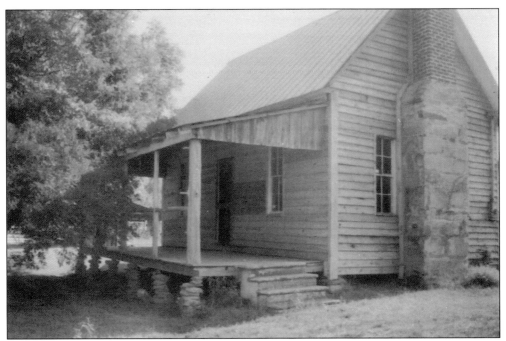

The Worley cabin underwent changes when Redger Worley, a son of Reuben, moved his family into the dwelling later in the century. The front view of the cabin as it appears at present shows the additions—porch, large room, and chimney—that were erected before the 1950s.

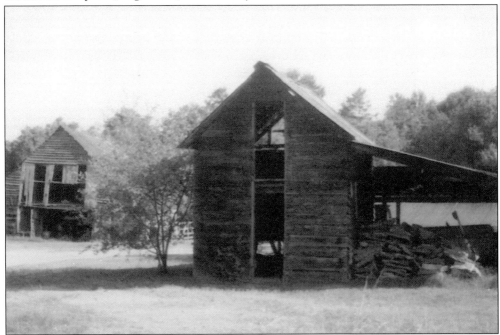

The barn and smokehouse, as these on the Worley homestead, were essential outbuildings on any farm. While the barn housed livestock, hay, and fodder, the smokehouse served as the processing and storage room for the family's meats, which could either be hung on pegs or salted away in the meat box.

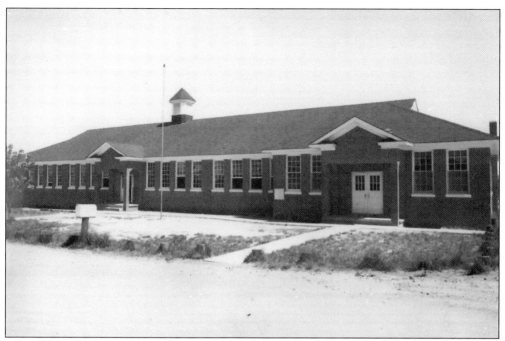

When the old Matt School—a wooden building—burned, students attended classes in the Zion Hill Baptist Church until a grand school building could be constructed in the mid-1940s. The new brick edifice, known as Matt High School by 1948, was the pride of the community. Citizens of the area eagerly assisted in its beautification through landscaping and other improvement projects.

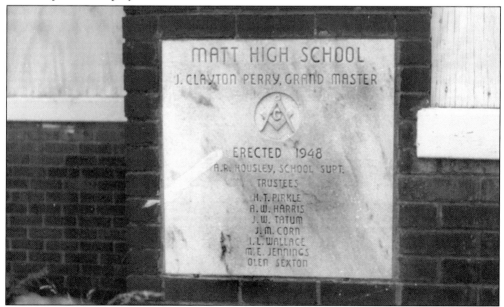

The cornerstone indicates that Matt School was erected in 1948. However, classes in the elementary grades commenced about three years earlier. The building was constructed during the administration of School Superintendent A.R. Housley. The first trustees were H.T. Pirkle, A.W. Harris, J.W. Tatum, J.M. Corn, I.L. Wallace (Wallis), M.E. Jennings, and Olen Sexton.

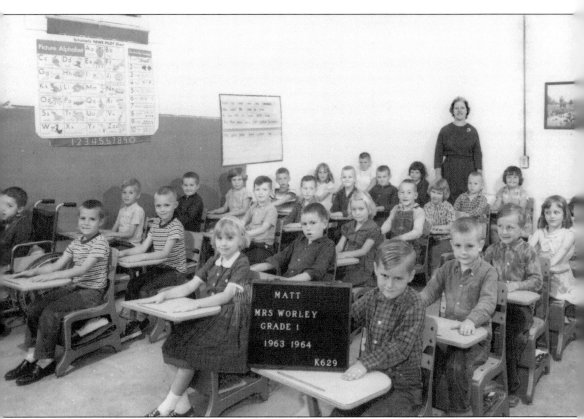

Maggie Harrison (Mrs. Redger) Worley, who taught at Matt during the entire period of the school's existence, is pictured with her first grade class in 1963–1964, who are diagonally, from left to right, as follows: (first row) Steve Yother, Van Mason, Ronnie Hamby, Anita Bertrand, Patty Hudgins, Jane Pilcher, and Tim Blanton; (second row) Jimmy Westray, Jerry Frix, Gary Densmore, Ricky Hamby, Jimmy Turner, Randy Nichols, and Jackie Mooney; (third row) Annette Free, Tony Evans, Diane Hamby, Davis Pilcher, Denice Cantrell, Gary Gilleland, and Pamela Yarbrough; (fourth row) Horace Butler, Ricky Mathis, unknown, Kathy Pruitt, unknown, and Vicky Lark. These students were transferred to Sawnee Elementary in 1968 when Matt, Friendship, and Ducktown schools were consolidated. Incidentally, Mrs. Worley taught all four of her own daughters—Lewellen, Sue, Nancy, and Barbara—during her tenure at Matt. Following the school's closing, the building has been converted to house a business, Carpet Depot.

A.W. Harris was one of the original
trustees of Matt School and one
of the oldest members of the
community. Schools, such as Matt,
constructed during the first half of the
20th century, tended to be the center
of social life in their communities.
Plays, carnivals, class programs,
and other functions were held in
auditoriums, such as the one where
Mr. Harris is pictured. (Courtesy
of the family of Maggie Worley.)

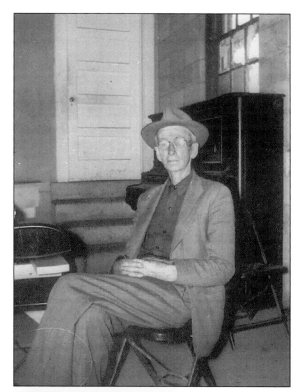

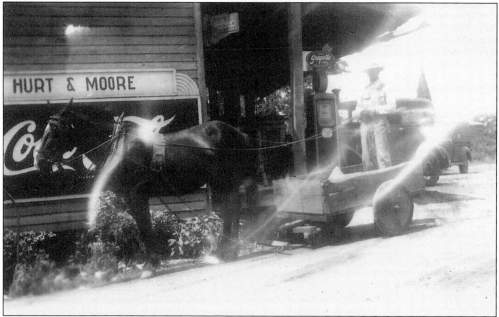

In front of Hurt and Moore's Store, Egbert Sexton drove his "sled." The store, which sold
general merchandise to farmers, was situated at the corner of the present-day Highway 369 and
Bannister Road. Roy Moore, who ran the store for many years, referred to the antiques within as
"old junk" but would not part with them. The building burned and was later replaced by Leon's.
(Courtesy of Preston Worley.)

Jerry Byers served as one of the first officers, Junior Warden, of Matt Lodge Free & Accepted Masons, which held its first communication on March 24, 1949. He was the last living charter member at the end of the century. The lodge hall is located on Highway 369 and John Burruss Road across from the intersection with Bannister Road.

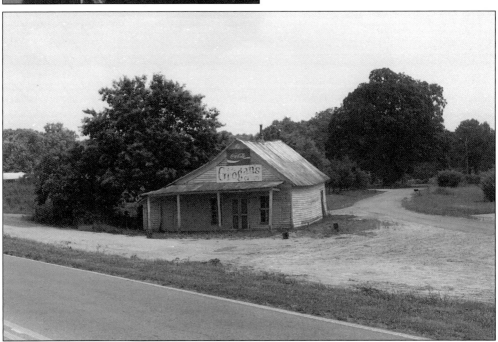

Grogan's Store, situated diagonally on Bannister and Namon Wallace Roads across from Matt School, was a favorite gathering place for old timers before it closed in the 1990s. The building has since undergone renovation for an office and sits pristine in its location adjacent to a busy road—a reminder of the Matt of yesteryear. (Courtesy of Tom Constantine.)

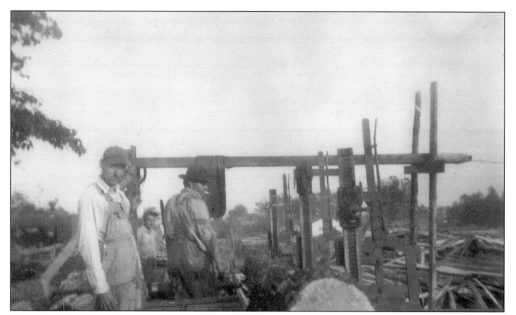

John F. Harrison, the progenitor of the Harrisons in Forsyth County, brought the sawmill industry to Matt. Since the early days of the business, other Harrisons have taken up the trade, which has seen a host of changes over the years. With the invention of the gasoline engine, the sawmill industry was revolutionized. (Courtesy of the family of Maggie Worley.)

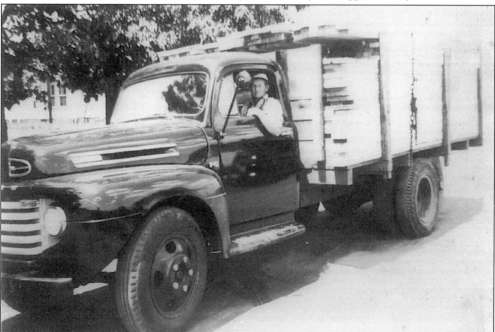

The method of hauling lumber from the sawmill changed also. No longer did horse-drawn wagons transport the products of the mill through the countryside. In the 1950s, trucks were utilized in hauling lumber, although most roads in the county remained unpaved. Within the next 20 years, however, more miles of pavement would aid in transporting the output from the mill. (Courtesy of the family of Maggie Worley.)

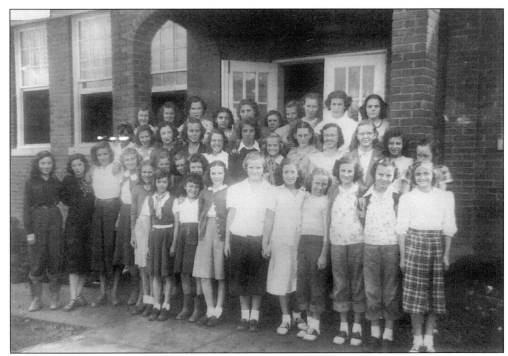

These 4-H girls are pictured in front of Matt School, where they met to plan and present results of projects. From raising hogs and chickens to gardening and food preservation, the young ladies pursued agricultural activities with enthusiasm and perseverance, and lived farm life to the fullest. (Courtesy of the family of Maggie Worley.)

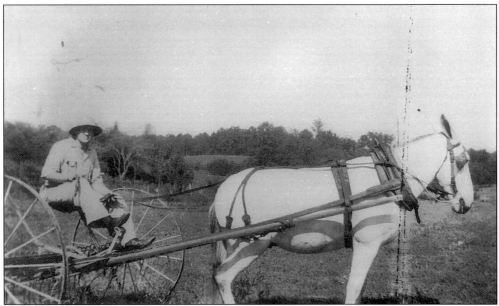

By 1950, the old ways of farming had not completely given way to the new. The mule and hay rake pictured here is an example of a traditional farming method. The lady on board the rake appears to enjoy her work, while the mule has a healthy appearance. (Courtesy of the family of Maggie Worley.)

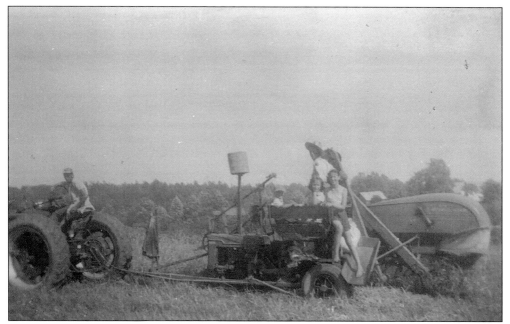

Farm machinery, crude though it was by today's standards, gradually replaced the mule- or oxen-drawn implements. The driver on this tractor is unknown, but on the threshing machine are Redger Worley and two of his daughters, Lewellen and Nancy, at work on their farm. (Courtesy of the family of Maggie Worley.)

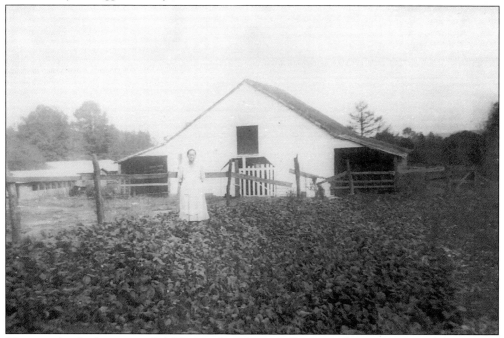

This scrapbook photo, entitled "Greens for Winter," illustrates the importance of the family's vegetable garden. Gardens were planted with extreme care, for the family's food supply depended upon them. The fence around this garden was likely to protect the growing plants from the family's livestock. (Courtesy of the family of Maggie Worley.)

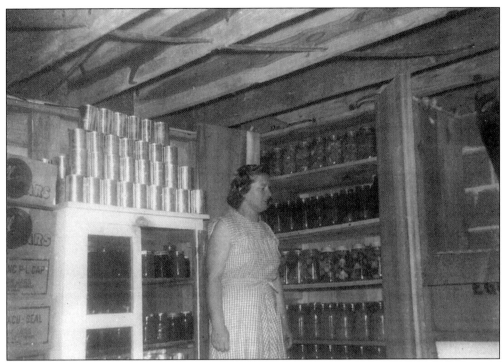

Maggie Worley takes stock of her canned goods, which were prepared from the products of yard and garden. These jars were shelved in the basement of her house in readiness for the coming winter. As the popularity of canning grew, Home Extension Agents were available to advise homemakers how to preserve their vegetables and fruits safely. (Courtesy of the family of Maggie Worley.)

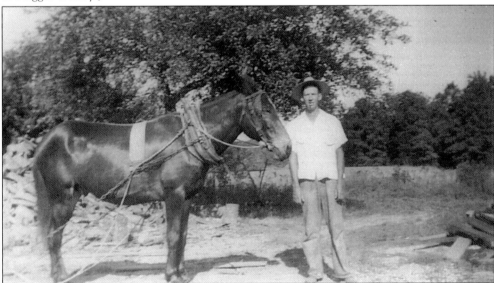

Hulet Milford had not yet traded in his fine mule for a tractor when this photo was taken. As the years passed, however, the draft animals, which were the power behind the farms of the early years, would eventually be replaced by simple tractors, which themselves would become outdated as more modern versions took their place. (Courtesy of the family of Maggie Worley.)

The chicken industry saved the local farmers and their families from extreme poverty at a time when drastic measures were needed. The Depression, a drop in cotton prices on the world market, and the boll weevil had ruled out farming as a livelihood for farmers in the South. Not only would the prices not support those attempting to maintain cotton as their "cash crop," but the land in Forsyth County was unsuited for raising cotton as well. When the worn-out, eroded farms could not sustain their tenants, farmers turned to a new crop—hot house chickens. With chicken houses springing up over the countryside, Wilson and Company opened a processing plant in Cumming and the chicken business was in full gear. By the late 1940s, a noticeable rise in the standard of living could be observed. Pride in home and community followed closely thereafter. (Courtesy of the family of Maggie Worley.)

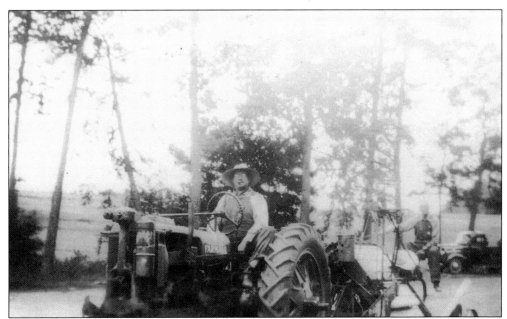

Raising chickens enabled farmers to improve their lot in life for the first time in decades. With cash in hand, many aspired to own mechanized equipment, such as the Farmall tractor, pictured here. By 1950, one could observe improved housing as well as lush fields that were fertilized by the litter from the chicken houses and worked by the new modern farm machines. (Courtesy of the family of Maggie Worley.)

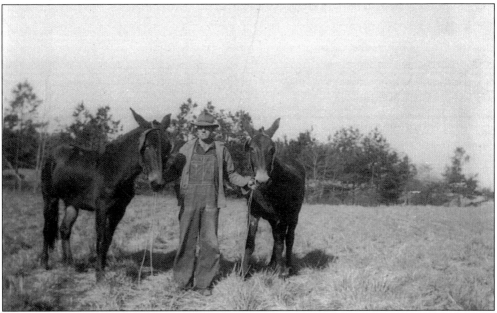

In the late 1940s and early 1950s, farmers throughout the county posed in their fields to record for posterity an amazing new herb—fescue. Pastures and roadsides that were previously eroded or worn out were suddenly greening with the planting of the wonderful grass. It is not a coincidence that the mules standing with their owner appear fat and sassy. (Courtesy of the family of Maggie Worley.)

Ducktown community was agriculture based, and the township, chartered in 1912, was its hub. The warehouses, general store, blacksmith shop, and other businesses sprang up to serve the agrarian needs of the citizens. Pictured to the right are L.T. Ledbetter Sr. and his wife, Loma, in 1900. Ledbetter, who owned the general store, would become the township's first mayor. (Courtesy of Catherine Ledbetter.)

L.T. Ledbetter is shown here in 1956, years after the principal businesses had burned, the general store had been downsized, and Highway 20 had been paved and rerouted away from the township. It had been at least two decades since Ducktown had had an active government or commerce was carried out to any significant extent. (Courtesy of Catherine Ledbetter.)

21

L.T. and Loma Ledbetter appear to be reflecting on the once-burgeoning township of Ducktown. At the time of the photograph, the Ledbetter house at the crossroads of Heardsville and Gold Mine Roads still bore eloquent testimony to the community that once existed. Today, however, the house is gone because it burned years ago, and the only significant activity seems to be the thriving New Harmony Baptist Church nearby. (Courtesy of Catherine Ledbetter.)

Time marched on, and in 1957, L.T. Ledbetter enjoyed his numerous great-grandchildren, pictured here, from left to right, as follows: (front row) Charlotte, holding Buster, Kathy, Chip, Jimmie Jean, Sandra Dean, and Sally; (back row) L.T. Ledbetter, Gail, Ginger, and Joy Anne. Linda and Marsha are in front of the porch post. (Courtesy of Catherine Ledbetter.)

Two

AGRICULTURAL HERITAGE

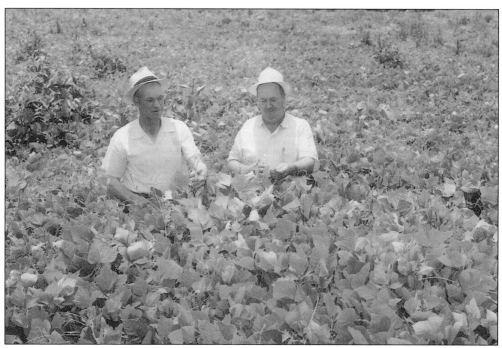

Soil erosion reached critical proportions in the 1940s, forcing a call for desperate measures. Farmers began an experimental practice of planting an imported vine called kudzu on banks and eroded lands. W.J. Orr, Forsyth County Soil Conservation Service supervisor, and J.T. Coots, soil conservationist, examine a lush growth of kudzu on Mt. Orr's farm. (Courtesy of Soil Conservation Service.)

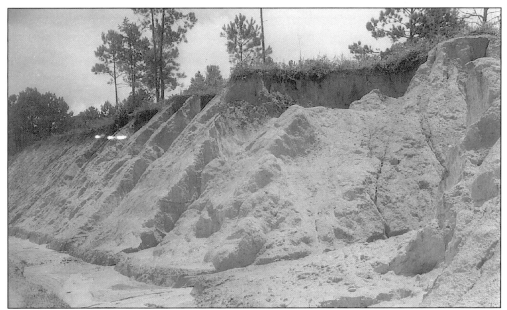

Before erosion control practices were instituted, the condition of banks was at their worst. This roadbank, approximately 15 feet high, is near the intersection of two highways. Its appearance illustrates the condition of roadsides throughout the county. Fortunately, within a few years, soil conservation practices would reverse the depletion of topsoil throughout the area. (Courtesy of Soil Conservation Service.)

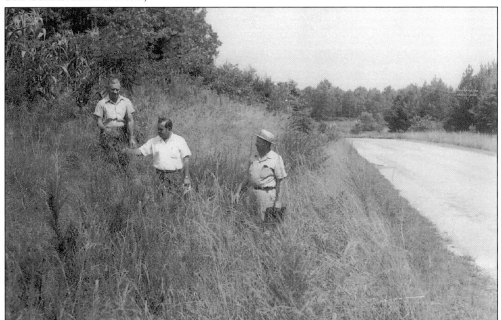

After the introduction of fescue and other grasses to Forsyth County, the scene was entirely different. With the new grasses able to hold the soil in place, erosion was controlled and topsoil was no longer being washed away with every rainfall. In this photo, three gentlemen inspect a planting of tall fescue, love grass, and sericea lespedeza along a roadside bank. (Courtesy of Soil Conservation Service.)

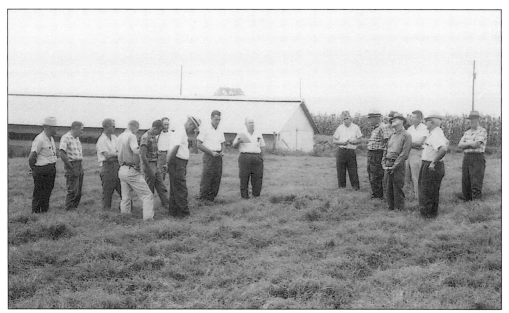

Soil conservation supervisors and agricultural workers study a planting of Coastal Bermuda on the A.C. Smith farm. By close monitoring of the grasses being introduced, these supervisors could determine the varieties best suited to North Georgia. Experiments in pasture improvements constituted one phase of a farmer's operations, such as on this farm where chicken production was paramount. (Courtesy of Soil Conservation Service.)

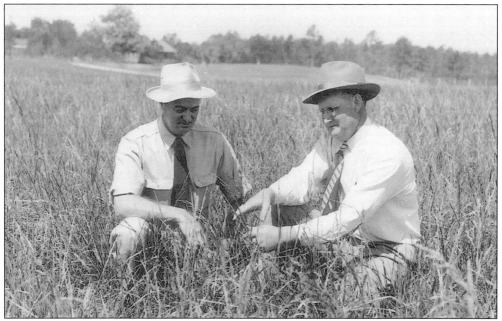

Kentucky 31 fescue was to become the leading grass on Forsyth County farms as it fulfilled several needs, including grazing for livestock, hay production, and soil erosion control. In this photograph, D.E. Nalley, owner, and F.W. Rickard, a certified seed grower in Winchester, KY, look over Mr. Nalley's seed patch of the experimental new grass. (Courtesy of Soil Conservation Service.)

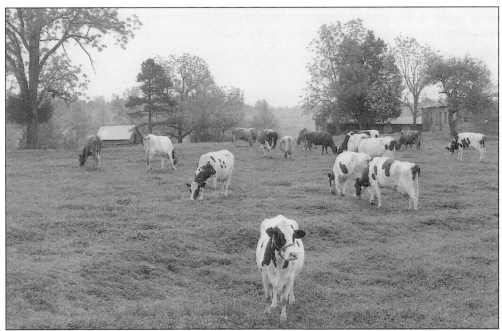

On the Holland farm on Route 5, a herd of commercial dairy cattle graze a field of four-year-old ladino and two-year-old Kentucky 31 fescue. This image was taken on May 5, 1950, after 75 cows and 40 hogs had grazed the pasture since September 1949. The Holstein herd grazing on this land produced an average of 110 gallons of milk per day. (Courtesy of Soil Conservation Service.)

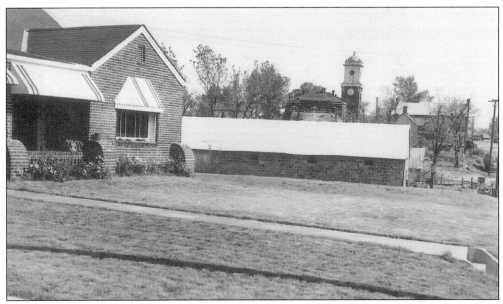

Fescue, as it turned out, was not only for pastureland and roadsides. Reverend Flanigan of Cumming boasted an experimental lawn of Kentucky 31 fescue just one block from the courthouse square. Although the house still existed at the end of the century, Reverend Flanigan's lawn was relegated to the past, for the widening of Old Buford Road claimed the property almost to the front door. (Courtesy of Soil Conservation Service.)

Edison Collins "E.C." Westbrook, a native of Forsyth County, was born on his father's farm near New Hope Methodist Church. Having attended the public schools of the county, he continued his education and received a B.S. in Agriculture from the University of Georgia in 1914. Subsequently, he engaged in graduate research at the University of Missouri. In 1931, Westbrook received a Master's Degree in Agriculture from the University of Georgia. He would later become a full professor at the university. His life's work, however, began in 1914, when he became associated with the University of Georgia Agricultural Extension Service. Through his work as an agronomist with the Extension Service, a position that he held for over 40 years, his expertise in growing cotton and tobacco received statewide acclaim. Westbrook was instrumental in the development of Sea Island cotton and in efforts to control the boll weevil. He traveled extensively and spoke to farmers about effective ways to improve their crops and published numerous booklets and pamphlets as well. (Courtesy of the Garland Bagley Collection.)

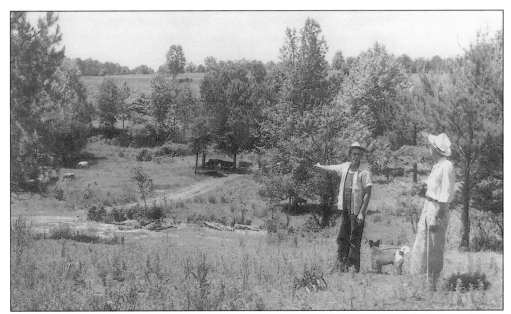

On the Settendown Creek subwatershed, J.C. Chumbler, left, indicates the area where a flood prevention structure on Thally Creek will be constructed. This photograph, taken in May 1957, depicts a common scene, as numerous dams were built on area creeks for flood and erosion control. Many of the ponds thus created were stocked with fish. (Courtesy of Soil Conservation Service.)

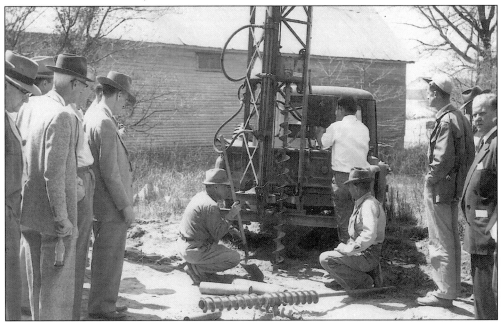

The casual observer might believe that a well was being bored from the activity indicated in this image. In reality, the soil was being tested to determine its suitability for the construction of a dam. Before a conservation dam was built, samples were taken to indicate the type of soil in the vicinity. Thus, the likelihood for the project's success could be determined before construction began. (Courtesy of Soil Conservation Service.)

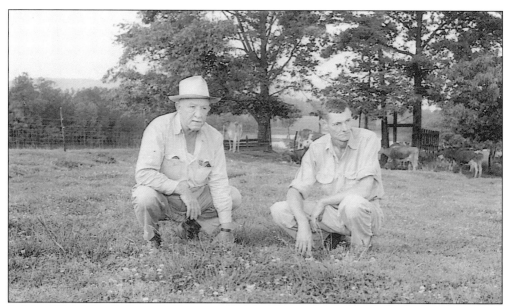

In May 1956, John C. Cates (left), conservation aid, and Ed Norrell, Soil Conservation Service district cooperator, are shown in an excellent white clover pasture on the Norrell farm at Coal Mountain in this photograph by J.W. Harwell. Clover, a legume, was planted to enrich overworked or overgrazed soil. (Courtesy of Soil Conservation Service.)

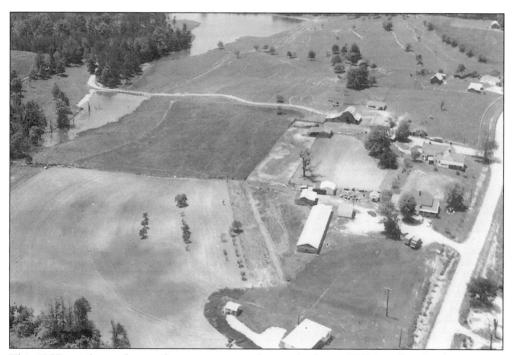

This 1957 aerial view depicts the conservation plan on the farm of Ed Norrell at Coal Mountain. With a dairy operation at the core of agricultural activities, the land was used for pasture, perennial hay, farm ponds, and woodland. Norrell also had the advantage of easy access to paved highways, not to be taken for granted in 1957. (Courtesy of Soil Conservation Service.)

Corn was widely grown in Forsyth County in 1942. This field, identified as belonging to Taylor Pirkle, contained 3 acres of corn on Cecil clay soil with an estimated yield of 40 bushels per acre. For the previous 3 years, the land had been sown in small grain and lespedeza. (Courtesy of Soil Conservation Service.)

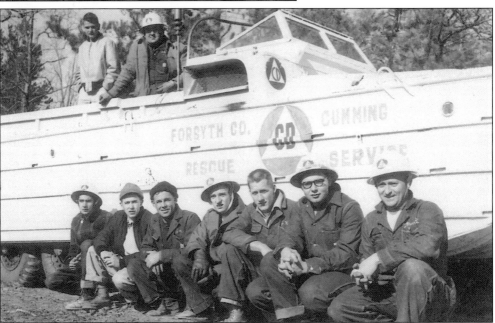

In 1959, "The Duck," as the Civil Defense vehicle was called, was pictured as the Cumming Unit assisted the Upper Chattahoochee River Soil Conservation District and watershed directors in unstopping a drainpipe. Pictured, from left to right, are the following: (on the ground) Durel Sexton, David Sutton, Avon Hughes, Gene Pruitt, Joel Glendon Webb, Joe Wheeler, and Cecil Merritt; (standing in the "Duck") Jerry Sexton and Roy Moore. (Courtesy of Soil Conservation Service.)

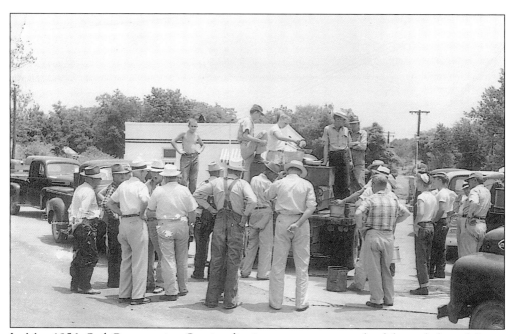

In May 1956, Soil Conservation Service district cooperators met the fish truck for a delivery of fingerling bream for their farm ponds. A U.S. Fish and Wildlife Service truck was used for transporting the fish to the waiting farmers. Forsyth County Soil Conservation Service Work Unit personnel assisted with the delivery. (Courtesy of Soil Conservation Service.)

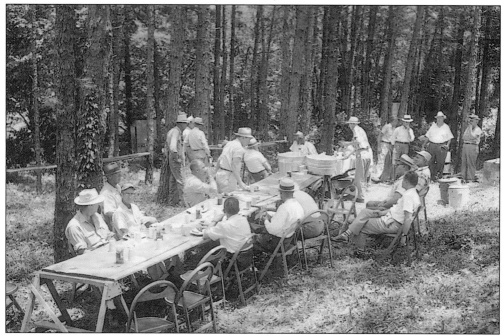

The board of supervisors, Soil Conservation Service personnel, and Etowah River Watershed directors prepared for a lunch meeting at Silver City on June 20, 1957. A field trip preceded the lunch and business meeting. Inspections of ongoing projects were frequently made to assess their progress. (Courtesy of Soil Conservation Service.)

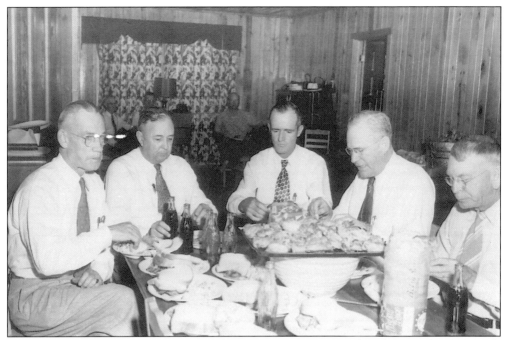

Enjoying a fried chicken dinner at the Club House in Cumming are, from left to right, O.D. Hall, assistant state conservationist of the SCS at Athens, GA; Dr. T.S. Buie, regional director of the SCS of Spartanburg, SC; C.W. Chapman, assistant state conservationist, SCS, of Athens, GA; and E.D. Alexander, extension agronomist of Athens. (Courtesy Soil Conservation Service.)

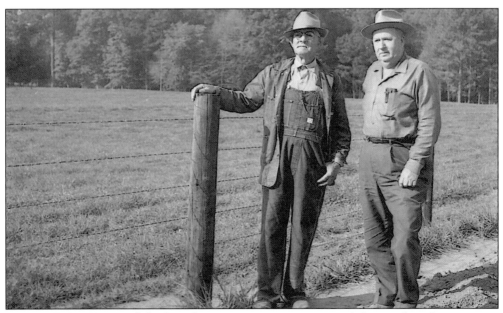

In 1962, R.A. Herring of the Brandywine community was named Outstanding Conservation Farmer of the Year. Herring (left) and James T. Coots of Forsyth County are here as they survey some of the practices that Mr. Herring carried out to earn the award. This photo was taken on October 30, 1962. (Courtesy of Soil Conservation Service.)

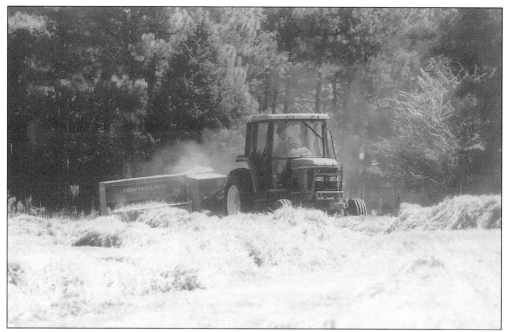

Gone are the days of harvesting hay with mule-drawn hay rakes. With this up-to-date piece of equipment, a farmer can complete the once arduous task of baling hay by utilizing an elaborate mechanized system. Except to step out occasionally to adjust the machine parts, he rides in air-conditioned comfort. Of course, the job of loading and hauling the baled product remains hot and itchy. (Courtesy of Soil Conservation Service.)

The compost building is another feature of modern agriculture. Litter from the chicken houses, not immediately spread on pastures, may be composted for future use through a process that promotes decomposition and retains the nutrients essential for fertilizing the soil. This building contains vents to allow air circulation through the material being composted. (Courtesy of Soil Conservation Service.)

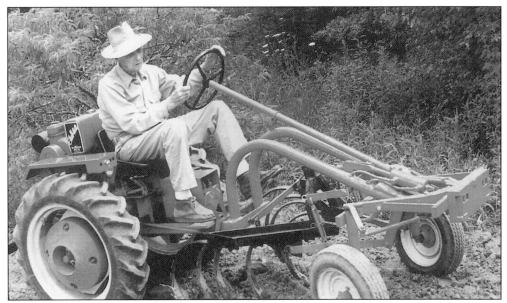

Arthur Sosebee, a gentleman well into his 90s, spent a lifetime working the land in the old time ways. But before reaching his 100th birthday, he adopted the modern method of farming by selling his mule, Bob, and purchasing a new tractor. He resided on Canton Highway across from Sawnee School and in this photograph can be seen plowing the garden beside his house. (Courtesy of Edith Wright.)

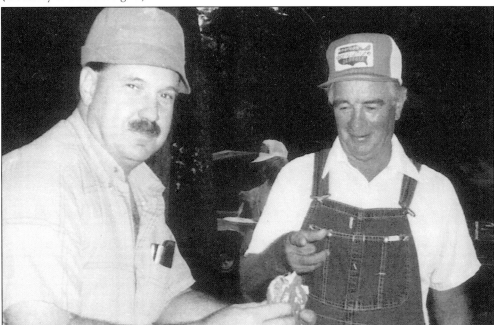

Lest one should believe that farming is all labor, the idea should be dispelled. Here farmers Michael Bennett and E.H. Reid enjoy barbecue at the Reid farm on the first day of dove season. For years, the Reids staged a barbecue for friends and acquaintances. After the over 100 guests consumed food from heaped tables, they then made their way to a dove shoot. (Courtesy of Soil Conservation Service.)

Three

AGRICULTURAL FESTIVALS AND AWARDS

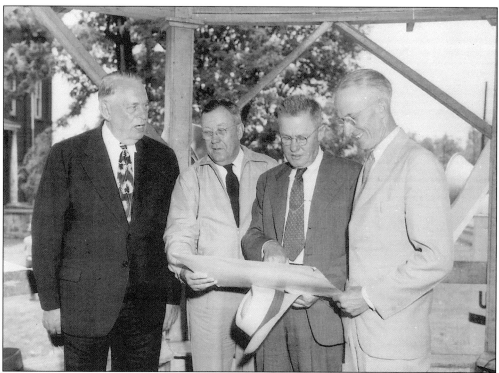

The success of new agricultural methods, which brought a higher standard of living to the citizens of Forsyth County, spawned festivals and celebrations and encouraged farmers by rewarding their efforts. Pictured from left to right on the bandstand at the Kentucky 31 Fescue Festival in Cumming on May 27, 1948, are Fred B. Wilson, T.O. Galloway, R.Y. Bailey, and C.M. Wade. (Courtesy of the Soil Conservation Service.)

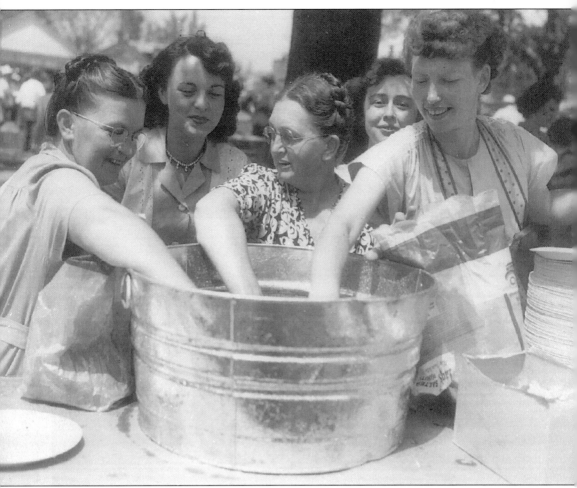

On May 5, 1949, these ladies were pictured as they served chicken to the crowds at the Kentucky 31 Fescue Field Day at Cumming. The emphasis on chicken as well as fescue is apropos, for chickens brought Forsyth County from widespread poverty to a more comfortable lifestyle. On this occasion the improvements resulting from the planting of fescue were not just praised from the courthouse square, but caravans—organized into manageable groups— toured the countryside to witness first hand the greening of Forsyth County. Then the crowd returned to town and assembled on the courthouse grounds for speeches and a lunch that was finger licking good. Cumming was filled with the individuals on hand for the festivities, and the farmers and their families, exhibiting pride in recent accomplishments, spread over the town square. Picnicking on the courthouse grounds was the order of the day. (Courtesy of the Soil Conservation Service.)

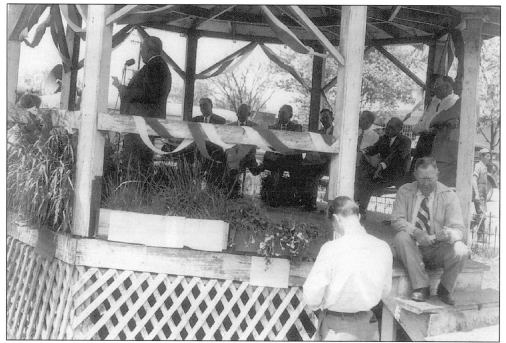

The 1949 Kentucky 31 Fescue Field Day brought leaders in agriculture to Cumming not only to honor the occasion but to offer their expertise as well. Channing Cope, master of ceremonies, and other leaders conducted the program on May 5 from the Cumming Bandstand with a sizable number of people converging on the square. (Courtesy of Soil Conservation Service.)

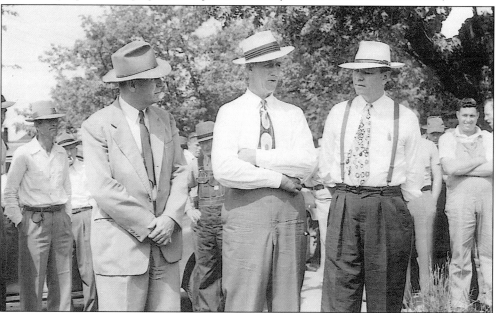

Politicians seem to have a natural affinity for crowds, and the gentlemen in the photograph were no exception. On hand to help celebrate the third annual Kentucky 31 Fescue Festival in Cumming were, from left to right, Lt. Gov. Marvin Griffin, W.M. Holland, and Gov. Herman E. Talmadge. (Courtesy of Soil Conservation Service.)

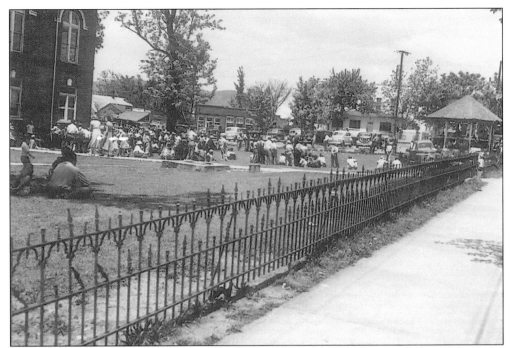

Backing away from the ceremonies on May 5, 1949, one may view the setting in which the festivities occurred. At the far left is the 1905 courthouse, surrounded by an iron fence, which was later removed. The bandstand on the far right sits near the intersection of Main Street and Old Buford Road. (Courtesy of Soil Conservation Service.)

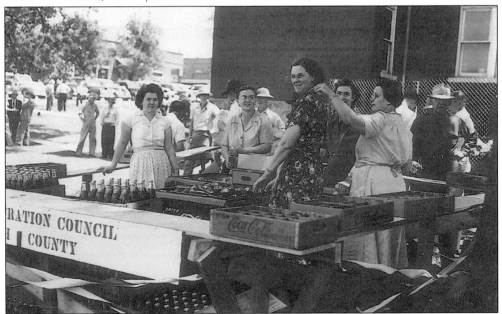

As the day wore on and the crowd became thirsty, these ladies were ready to assist. They were well prepared for the event with case after case of Coca-Cola on hand to slake the thirst of anyone seeking a cold beverage and to make a tidy profit for the organization they represented. (Courtesy of Soil Conservation Service.)

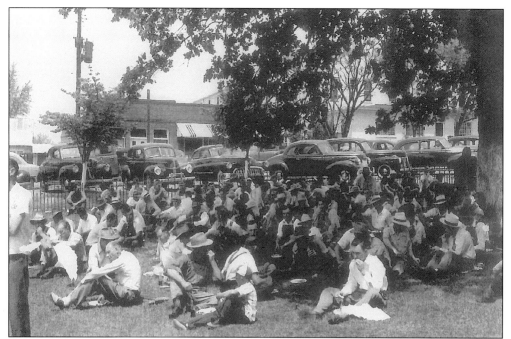

A popular place to spread one's lunch at the festival was under the shade tree on the north side of the square. Above the heads of the diners are some of the cars in which they arrived. Still farther in the background, to the right, is the Mashburn Hospital, formerly the Mashburn Hotel and years later the Cumming Convalescent Home.

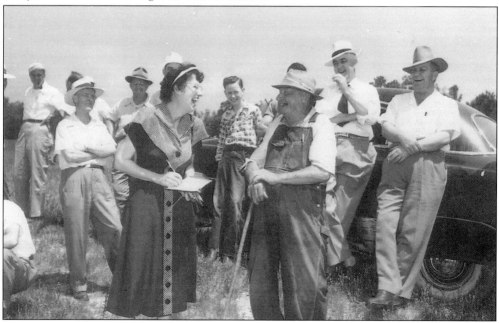

The festival tours were a crowd-pleasing experience. In 1952, Miss Vicars, seed analyst of Montgomery, AL, interviewed Smith Harrison, a 93-year-old farmer, when the motorcade stopped at his farm on May 9, during the fifth annual Kentucky Fescue Festival tour of Forsyth County. (Courtesy of Soil Conservation Service.)

In addition to a visit to the Smith Harrison farm, the motorcade made other stops to examine lush, thriving fescue fields. L.J. Sisk captured this image of the May 9, 1952 tour as well as the previous photograph. Ben Wofford, pictured here, was driving the lead bus with a host of vehicles

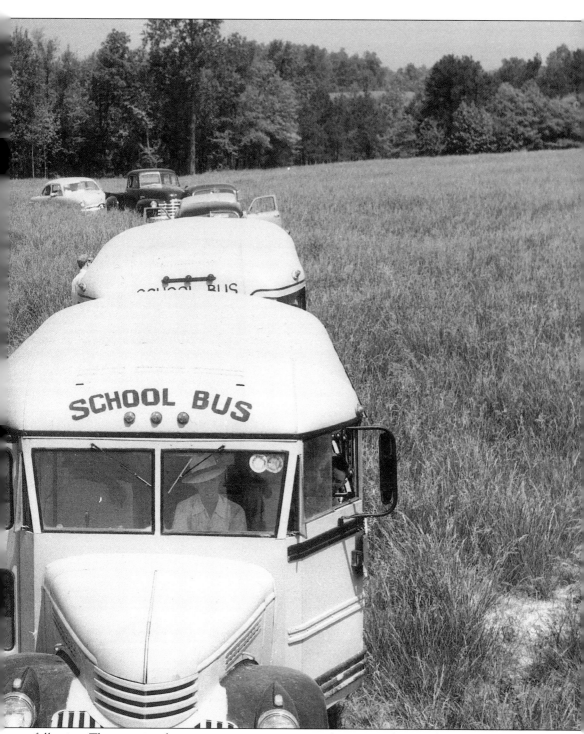

following. The occasion, however, was more impressive than meets the eye, for two more tours were canvassing different areas of the county at a season when the grass was at its peak—waving high in the fields awaiting cutting, raking and baling. (Courtesy of Soil Conservation Service.)

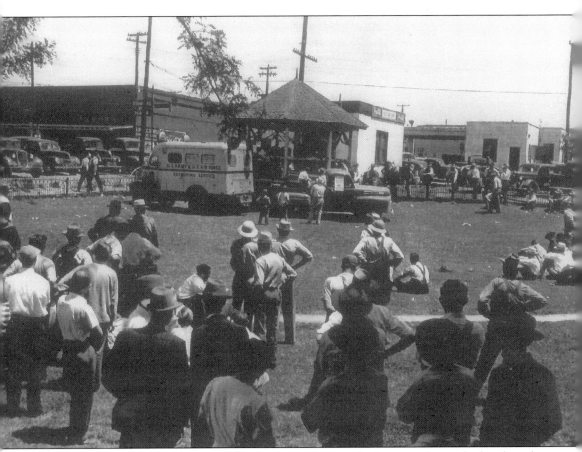

When the celebration returned to the square, the large gathering moved near the bandstand to hear the orations of the officials and to learn of recent improvements in the field of agriculture. As the people made their way to the center of the action, the view from the crowd's perspective included, on left, the corner building at Dahlonega and Main Streets known for years as the Cumming Drug Store. The service station, previously operated by DeWitt "Gilly" Thomas, Miles Wolfe, and others, that would later be converted to city hall and a fire station, could be seen to the immediate right of the bandstand. As traffic increased in Cumming, former mayor John D. Black, owner, had been under pressure from officials and citizens to remove this small structure because it allegedly obscured drivers' views at the intersection. Fire finally determined the fate of the building. A new off-the-square city hall was erected in 1974 to house city offices, a police department, and a fire station. (Courtesy of Soil Conservation Service.)

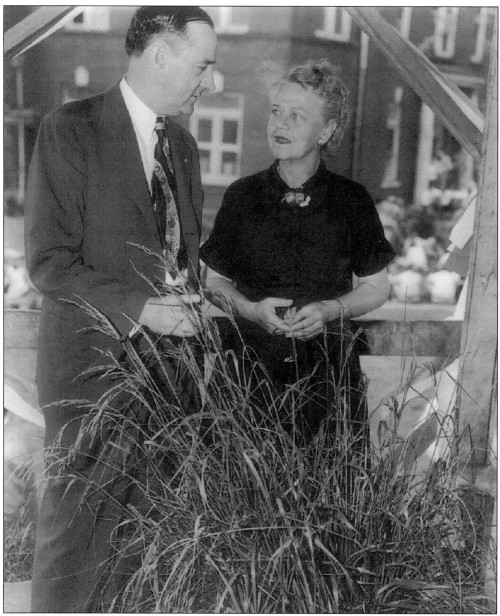

Cumming's most prominent citizens attended the Fescue festivals. Businessman Roy Otwell, chairman of the entertainment committee, was caught by the camera behind a healthy looking display of fescue at the bandstand in a discussion with Miss Susan Myrick, editor of the *Macon News*, at the third annual Kentucky 31 Fescue Festival. Roy Otwell was known for his business ventures, including his role in bringing the chicken plant to Cumming. He was a majority stockholder and president of the Bank of Cumming, owner of the *Forsyth County News* and the Ford dealership in Cumming, and engaged in numerous other business activities. In the political arena, Otwell served as mayor of Cumming, state representative, state senator, and member of the Forsyth County School Board. He and his wife, Lucille Bennett Otwell, were active members of the First Baptist Church. The couple reared their family in a brick dwelling north of the square on Dahlonega Street. (Courtesy of Soil Conservation Service.)

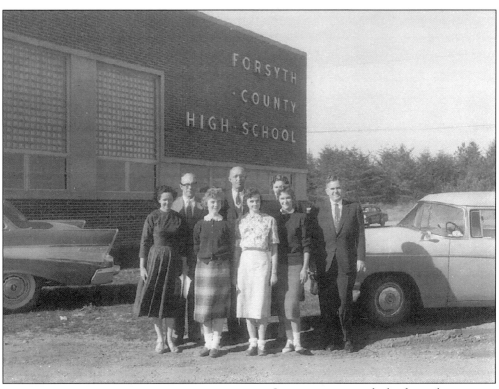

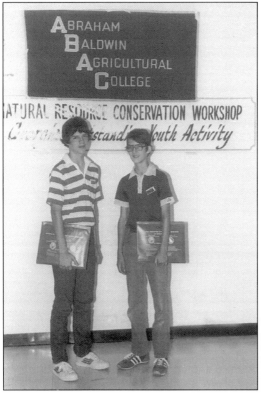

In conjunction with the festivals, students participated in conservation essay contests. This group from Forsyth County High School consists of the following, from left to right: (first row) Ado Coots, teacher; Carolyn Pulliam, third prize winner; Marjean Whitt, second prize winner; and Gladysteen Garner, first prize winner; (back row) W.J. Orr, district supervisor; Gordon Roundtree, Bank of Cumming; Edith Pulliam, teacher; and C.N. Lambert, principal. (Courtesy of Soil Conservation Service.)

The emphasis on agricultural studies was promoted in the Forsyth County Schools, especially at the high school level. Aspiring future farmers were chosen to attend workshops at Abraham Baldwin Agricultural College. The summer programs that were offered for youth encouraged teens to stay on the farm. These two young men received awards for their efforts. (Courtesy of Soil Conservation Service.)

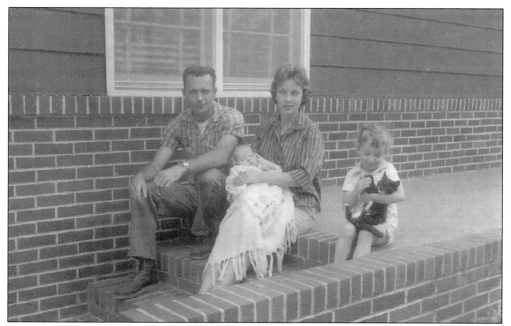

In 1959, the Emory Martins were chosen Outstanding Conservation Farmers for the year. Pictured, from left to right, are Mr. and Mrs. Emory Martin with Heidi, three months old, and Kristi, four years, on the steps of their modern home in the Coal Mountain community of Forsyth County. (Courtesy of Soil Conservation Service.)

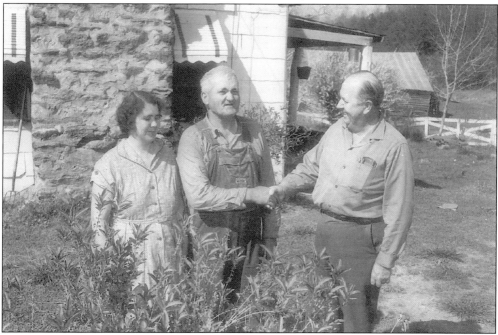

On April 16, 1959, Mr. and Mrs. G.W. Bragg—pictured beside their home—were congratulated by James T. Coots of the Soil Conservation Service for their conservation efforts on the Settendown Creek Watershed in Forsyth County. Bragg was chosen Outstanding Soil and Water Conservation Farmer for 1959. (Courtesy of Soil Conservation Service.)

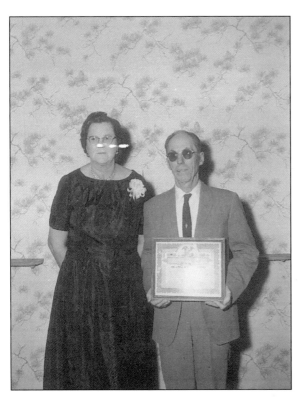

The 1965 Outstanding Conservation Farm Family from Forsyth County was the Winfred Waldrips, who were accorded the honor at Gainesville, GA, on November 30, 1965. The Waldrips' exemplary conservation practices were carried out in the Upper Chattahoochee River Soil and Water Conservation District. (Courtesy of Soil Conservation Service, Leon Sisk, Photographer.)

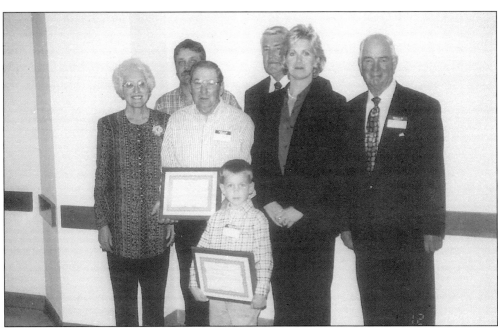

The Holtzclaw family was declared the 1999 Farm Family of the Year in Forsyth County. Pictured from left to right are as follows: (front) Drew Holtzclaw, holding a certificate; (second row) Shirley Holtzclaw, Marcus Holtzclaw, holding a certificate, Pam Holtzclaw, and E.H. Reid; (back row) Tim Holtzclaw and Leonard Ridings. (Courtesy of Soil Conservation Service.)

Four

BRIDGES AND STREAMS

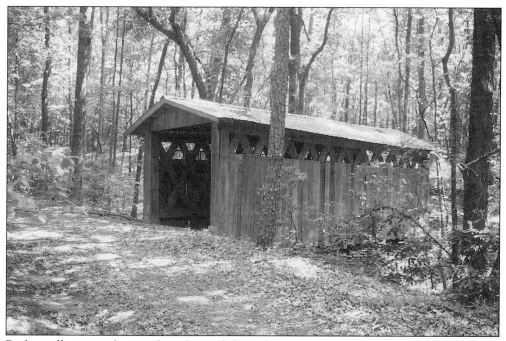

Bridges offer scenic beauty that almost defines the character of a community. They may be dated by type and construction to offer a sense of history as well as utility. Burnt Bridge, above, once spanned Settendown Creek, but fell into disrepair and was replaced by an iron bridge at the site. The covered bridge was purchased by Dr. Jim Mashburn and rebuilt on his estate.

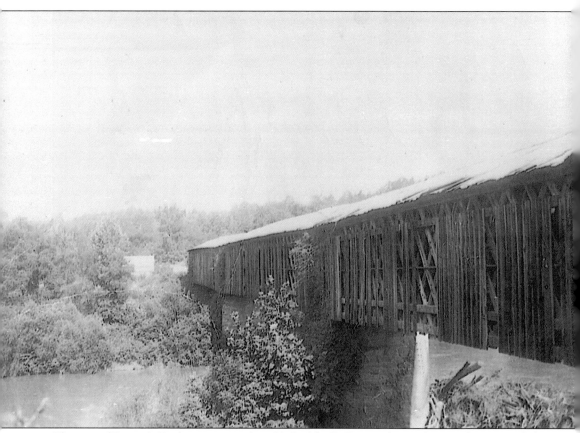

The site of Brown's Bridge was near the old Goddard's Ferry, where white traders crossed the Chattahoochee River into Cherokee Indian territory en route from Hall County to points west. A road was constructed to connect the settlement near the ford to the Federal Road. Probably the first bridge ever built over the river was on the property of Minor Winn Brown, who resided in the area before 1830 and who subsequently became a Gainesville postmaster and merchant. Brown was authorized to build a toll bridge at the site of the ford in 1839. The span across the Chattahoochee would have to be replaced several times as a result of destruction by natural forces. The owner of the bridge in 1898, Bester Allen, sold the span to Hall and Forsyth Counties, and it thus became toll free. The last covered bridge, above, was erected between 1898 and 1901 by a member of the King family of Columbus, GA. (Courtesy of Carolyn Nuckolls Baker and Charles Robb.)

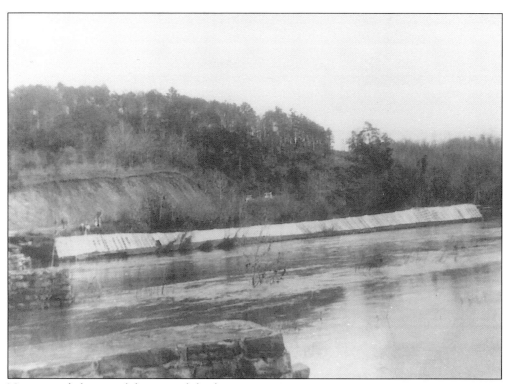

Nature tended to wreak havoc with bridges. Flooding, tornadoes, and weathering shortened the years of service that could be expected from spans crossing rivers and streams. Brown's Bridge succumbed to rising waters in early 1947. The flood washed the bridge from its supports and deposited it on the Hall County side of the Chattahoochee River. (Courtesy of June Martin.)

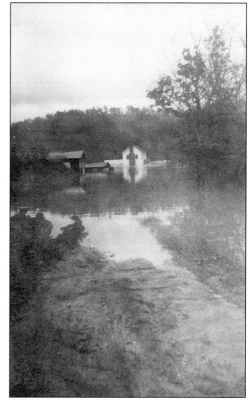

Travelers on the road from Forsyth County to Gainesville must have experienced shock and horror at the sight that greeted them in 1947. The roadbed, which led to the bridge, simply ended at the swollen river. Automobile access between the two counties was cut off at one of the main river crossings. This photograph was taken on the Forsyth County side of the Chattahoochee.

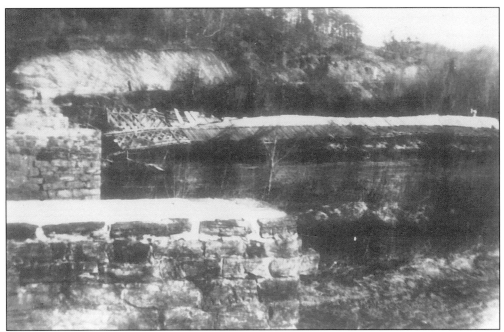

This image offers a second view of the bridge destruction caused by the flood of 1947. Brown's Bridge rests against the banks on the Hall County side of the river. Ten years later this entire area would be under water as Lake Sidney Lanier began to fill after the construction of Buford Dam.

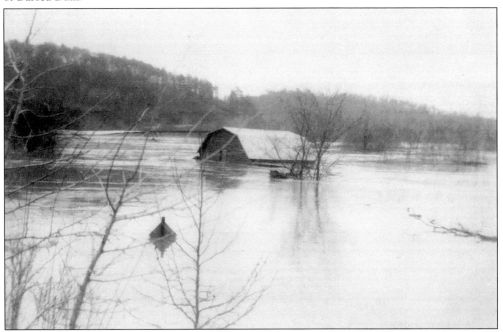

Dewey Mathis' barn was lifted off its foundation as floodwaters rose. The Chattahoochee River was out of control and causing widespread ruination as it flowed southward. This poignant photograph could have been used to establish a strong case for the flood control that Buford Dam would provide by the late 1950s.

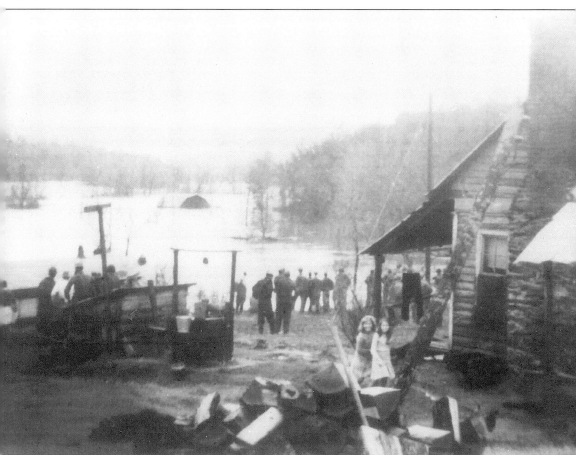

Residents of the area along the Chattahoochee look on incredulously as Dewey Mathis' barn floats down the river with chickens roosting in the loft. At the time of the flood, Mathis resided in the former home of Minor W. Brown. It is unknown how many homes were lost in this particular flood alone or the extent of other property damage and loss of livestock. The citizens who gathered along the Forsyth County side of the river were virtually powerless to save anything within the water's reach. When the floodwaters receded, a Bailey Steel Bridge was erected to replace the covered bridge and to facilitate travel between Forsyth and Hall Counties at that site. Use of the steel bridge was short-lived, however, for it was removed in the 1950s as the Army Corps of Engineers began to flood Lake Lanier. (Courtesy of Carolyn Nuckolls Baker.)

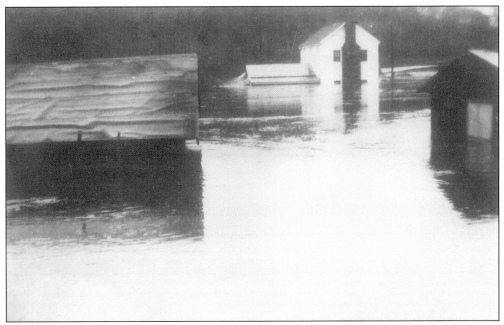

The river took its toll on the home of Minor Winn Brown, for whom Brown's Bridgewas named. Brown was the son of Willy Spiers Brown and Elizabeth Sloan Brown. Minor Brown, born June 19, 1797, married Messina Adams Holcomb on June 13, 1823, in Hall County. Their children included Perino, Warren A., and an unnamed infant. (Courtesy of Carolyn Nuckolls Baker.)

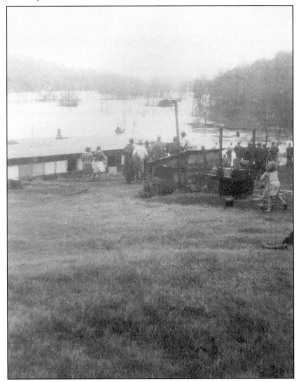

Another view of the 1947 flood depicts the movement of the Mathis barn down the Chattahoochee River. The people gathered on the bank observe Mother Nature's fury as the barn—livestock and all—are swept away. Brown's Bridge, too, was gone. Only memories remained of the last covered bridge, constructed of timbers from the Truman Lafayette Nuckolls place. The current Brown's Bridge was erected approximately one mile upstream from the site of the earlier bridges. (Courtesy of Carolyn Nuckolls Baker.)

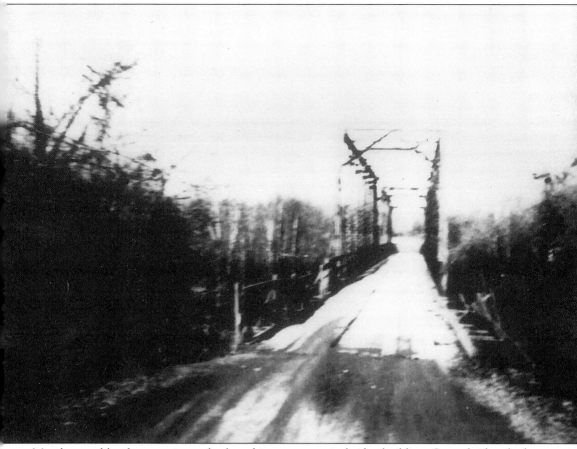

Metal spans like the one pictured ushered in a new era in bridge building. Stone bridges had sufficed for years, but in 1779, the first cast-iron bridge was constructed in Coalbrookdale, England. In the American South, plain wooden bridges and covered structures were utilized well into the 20th century. Then came a time when the wooden spans were being replaced by metal bridges. Forsyth County experienced the transition as bridges such as Burnt Bridge and Brown's Bridge were rebuilt as iron spans. The bridge shown above crossed the Chattahoochee on the highway to Flowery Branch. When Lake Lanier was flooded, efforts were made to save this span, but lake waters rose too rapidly for it to be dismantled and moved. Hence, the bridge to Flowery Branch lies beneath the waters of Lake Sidney Lanier. Incidentally, a more circuitous route must currently be followed should one wish to travel from the northern section of the county to Flowery Branch in Hall County.

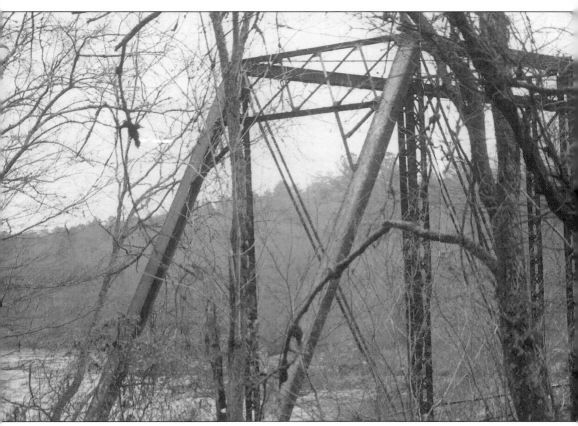

The frame is all that remains of Settle's Bridge in southeastern Forsyth County. Constructed during the era of the iron bridge, Settle's Bridge replaced the ferry, which had operated for decades. The Terry-Settle house nearby is a familiar landmark. In early days of the county, the road passed through the property owned by the Terrys and Settles and wound its way behind the house and down to the Chattahoochee River, where the Terry family operated a ferry. For a fee, travelers wishing to cross into Gwinnett County, or vice versa, could be floated across. However, times changed and the automobile necessitated an easier means of access between the two counties. When it came time to construct the iron bridge, the direction of the road was changed, a new segment constructed, and the site for the span was located upstream from the original ferry. Then, when times changed again, concrete bridges replaced the iron ones—including Settle's Bridge. The old iron span fell into disrepair and was closed to traffic. (Courtesy of the late Tom Atkins.)

When studying the streams of the county, one must consider the effects of silt on these waters. Before plantings of fescue and other soil retaining grasses were carried out in the 1940s and 1950s, silt from eroding banks frequently washed into creeks and rivers. C.L. Veatch and J.T. Coots are pictured measuring an accumulation of silt in the Settendown Creek Watershed. (Courtesy of Soil Conservation Service.)

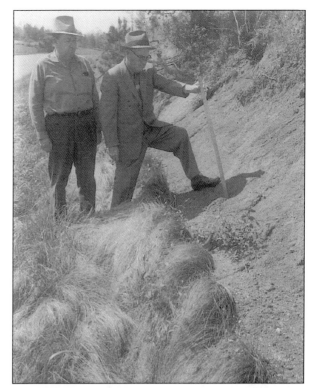

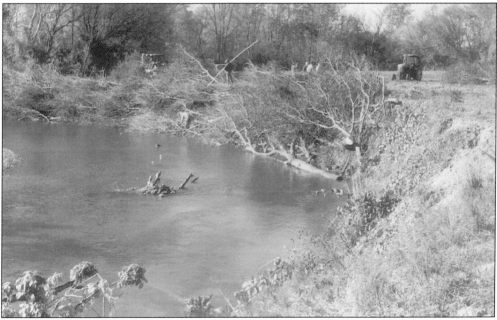

During the mid-20th century, numerous dams were constructed and ponds established on private farms. Not only did these dams and ponds establish flood control, but they also served to retard soil erosion. One might guess that branches were placed in the edge of this pond to provide breeding spots for fish. Not so—the debris was so placed to prevent erosion. (Courtesy of Soil Conservation Service.)

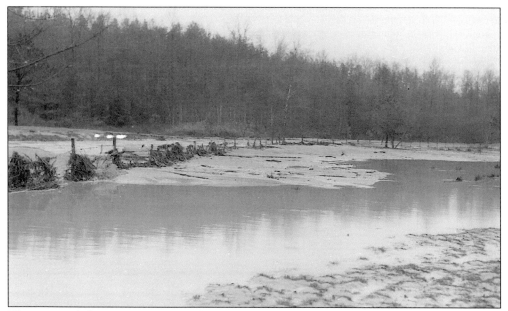

The rivers of the county were troublesome when heavy rains precipitated flooding. Lesser streams presented their share of problems, too. Pictured here is Settendown Creek during the rainy season when its waters left the creek banks and flooded adjacent land. A view upstream from Hurt Bridge shows the R.F. Hardeman farm as it had been inundated by the overflow of the stream. (Courtesy of Soil Conservation Service.)

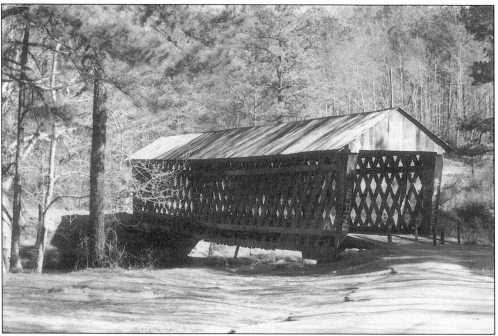

Settendown Creek went on a rampage in 1899 and washed away the existing bridge on the Poole's Mill property. This covered bridge was then erected in 1901 by Bud Gentry to enable travel to and from the mill and to the nearby communities of Heardsville and Frogtown. The span is now one of the few covered bridges that remains in Georgia.

Five

Noted Individuals and Groups

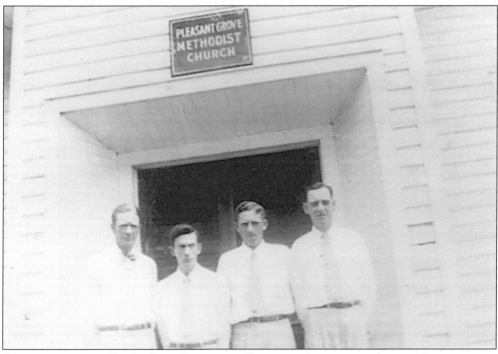

As singings, especially the June Singing in Cumming, became popular, vocal groups were organized to participate at the various events. The Pleasant Grove Quartet began with the talents of Q.L. Gilbert, John Holbrook, J.C. Wallace, and Broughton Wallace, pictured here from left to right. Later, Linda Wallace Walraven replaced J.C. Wallace and Joyce Wallace Hawkins served as pianist. (Courtesy of Joyce Wallace Hawkins.)

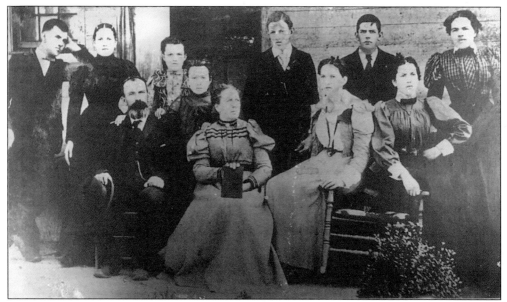

The Woodliffs were a prominent family of Forsyth County. They are pictured, from left to right, as follows: (seated) Augustus Woodliff, Mary Rice Woodliff, Mae, and Addie; (standing) Thomas Jefferson Woodliff, Mary Jane, Mattie Maude, Pearl Elizabeth, Benjamin Rush, Major, and Susan. Augustus Woodliff served in the state legislature and introduced the legislation that incorporated the township of Ducktown. (Courtesy of the Garland Bagley Collection.)

George W. "Spruill" Owen and his wife, Fannie, resided in the present Jot 'em Down community of northern Forsyth County. His father, Wiley Owen, had migrated from South Carolina to Georgia. Spruill was born May 15, 1844, in Forsyth County, married Fannie Martin, died April 21, 1931, and was buried at Salem Baptist Church. (Courtesy of George Welch.)

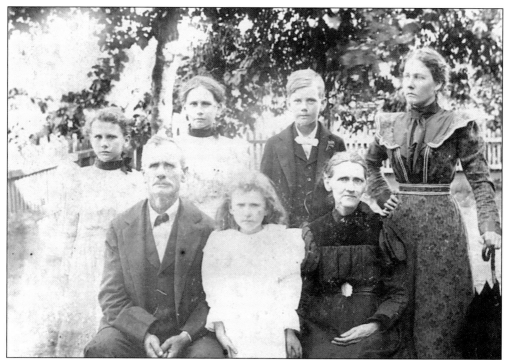

Members of the Jack Childers family were also associated with the present-day Jot 'em Down community. Pictured here, from left to right, are the following: (seated) Jack, Clara Bell, and Mary Carolina Owen Childers; (standing) Alice, Azalee, Lawton, and Cora Childers. (Courtesy of George Welch.)

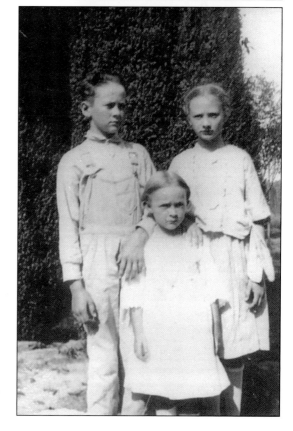

From left to right, Garland C., Marie, and Blanch Bagley are the children of Clarence "Dolly" Bagley and Creola Scales Bagley. The Bagleys resided in a folk Victorian dwelling in the Sharon community. Garland Bagley, a Forsyth County historian and author, amassed the data and photographs known as the Historical Society's Garland Bagley Collection. (Courtesy of the Garland Bagley Collection.)

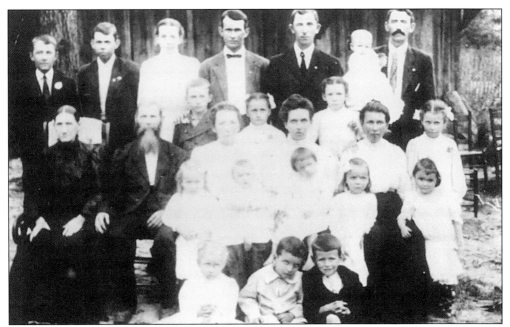

The Harvey Mashburn Pruitt family, pictured in 1910, from left to right, are as follows: (front row) Cora Harris, Toy Pruitt, and Eldon Pruitt; (second row) Bertie Harris, Laban Pruitt, Lizzie Pruitt, Hazel Harris, and Ollie Pruitt; (third row) Sarah Pruitt, Harvey M. Pruitt, Minnie Harris, Ada Pruitt, Mary Ann Pruitt, and Dura Pruitt; (fourth row) Louie Harris, Ora Harris, and Eda Pruitt; (back row) Lester Harris, Lee Pruitt, Sarah Pruitt, Monroe D. Harris, Asbury Pruitt, and Frederick Pruitt, who holds Alfred.

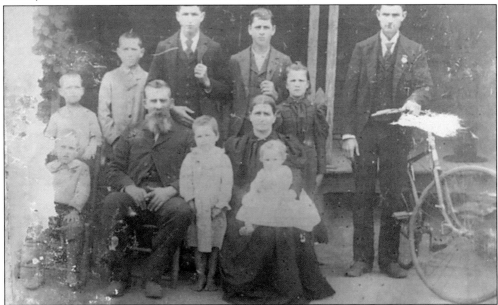

The D.W. Elliott family, pictured from left to right, are as follows: (first row) Gober, Wansley Elliott, and Ovie in the mother's lap; (back row) Gordon Rufus, Bige, Joe Harriett, and Bunyon. Not pictured are Jep, George, Julia Tatum, Odessa Smith, Lizzie Gunter, and Maggie Cox. (Courtesy of Garland Bagley Collection.)

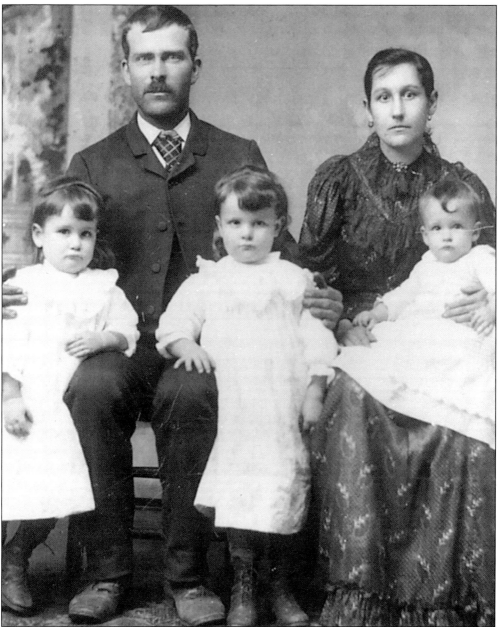

George William Fagan, born 1826 and died June 15, 1911, married Lucy M. Bagley. To this union were born six offspring: Mary L., born *c.* 1852; Sarah, born *c.* 1854; William H., born *c.* 1857; Susan, born December 2, 1859; Georgia Ann, born November 2, 1862; and James W., born December 27, 1866. The couple's sixth child, James W. Fagan, is pictured here with his wife, Cora McWhorter Fagan, and his three oldest children, from left to right, Lizzie, Eula, and Elzra. Seven children would be born after this photograph was taken. Their names were James Esner, Elmer, Edgar, Ursel, Everett, Claudia, and Cletis. The Fagans resided in the southern part of Forsyth County and many of the family members are buried at Pleasant View Baptist Church. Incidentally, this image was found in an old trunk that had been sold as an antique and was donated to the Historical Society of Forsyth County. (Courtesy of Betty Moulder Spruill.)

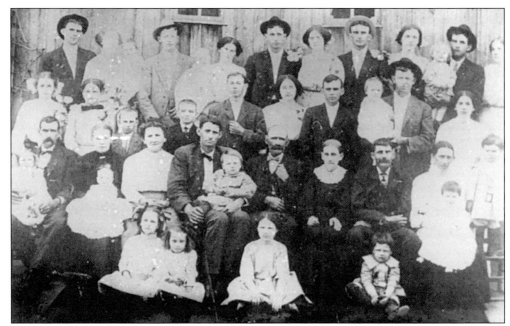

The Andrew Chappel Bottoms family pictured here, from left to right, are as follows: (front row) Maude Worley, Kate Bottoms (?), Dessa Worley, and Glenn; (second row) Ben Bottoms, Grace, Mary Ann, James, Sally, Jim Bottoms, Broughton, A.C., Nancy Jane, Reuben Worley, Frances Bottoms, Redger, and Willard Martin; (third row) Bera Bottoms, Minnie Worley, Ira Bottoms, Chap, Noah, Ida Worley, unknown, Harrison Martin, Louise, and Lillie Bottoms; (back row) identifications had to be omitted due to space.

The Pruitt-Hawkins reunion was held at the John Wesley Pruitt homeplace on Mount Tabor Road. The older generation, appearing in the second row, from left to right, are Pearl Stephens Pruitt, Paul Ray Pruitt (who holds Hoyt), Albert Webb Pruitt, Cora Harris Pruitt, Cicero L. Hawkins (holding Margaret), Lillie May Pruitt Hawkins, Dora Pruitt Hardin, Julia Jane Pruitt Wilkie, and Hanna Samaria Pruitt. (Courtesy of Rupert Sexton.)

Henry and Mary Olivia Hudson Foster, the daughter of John and Elizabeth Charity Moor Hudson, are the parents of the five children. They are, from left to right, as follows: (front row) Ruth, born 1892, married Jesse Hollingsworth; and John Lumpkin, born 1896, married Lula Roberts; (back row) Kate, born 1885, married Dr. DeWitt Jones; Maude, born 1883, married Cecil Cannon; and Joseph, born 1889, married Neel Stribling. (Courtesy of John and Emylie Foster.)

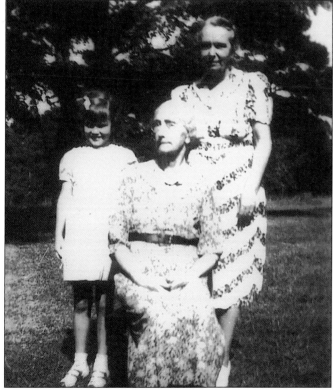

In the front is Mary Olivia Hudson Foster, who was born in 1860 to John Hudson, a wagon maker, and Charity Elizabeth Moor Hudson. In the back, from left to right, are Carol Ruth "Mamie" Jones, Foster's grandchild; and Foster's daughter Kate, who married DeWitt Jones, a physician of Alma, GA. Kate later moved to Florida and subsequently to Oregon. (Courtesy of John and Emylie Foster.)

Alice Harrell Strickland has the distinction of being Georgia's first woman mayor and the individual who donated a tract of land for the first community forest in the state. A native of Forsyth County, Alice Harrell Strickland, born June 24, 1859, was the daughter of Newton and Mary Ellender Harris Harrell. She married Henry Strickland Jr., her cousin from Duluth, Georgia, and raised a large family in addition to her civic accomplishments.

These four individuals were teachers—distinguished educators—at Friendship School. On the front row, from left to right, are Almon Hill, who would coach winning sports teams at Cumming School and serve as County School Superintendent; and Arthur Sosebee, whose career would span more than five decades as a teacher and principal. On the back row, from left to right, are Fleta Bramblett and Irene Roper Tallant. (Courtesy of Edith Wright.)

Will Rogers, cowboy star and humorist of yesteryear, was descended from a Cherokee Indian family of Forsyth County. Some of his ancestors are buried in the Sheltonville—or Shakerag, as the community is known—section of the county. After achieving stardom and winning the hearts of the American public, he was killed in an airplane accident in Alaska with aviator Wiley Post. (Courtesy of the Garland Bagley Collection.)

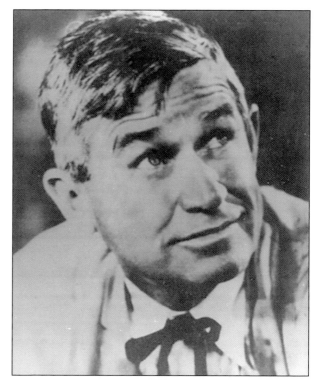

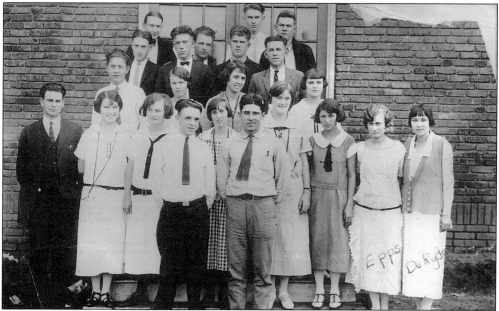

The Cumming High School Class of 1925 included the following, from left to right: (first row) C.H. King, Ineil Heard, Pauline Wallace, Huey Baker, Ruby Deen Merritt, Claude Singleton, Edith James, Violet Fowler, Elizabeth Epps, and Rachel DeRyder; (second row) Sam Orr, Corinne Pace, Johnnie Forrest, and Edith Stone; (third row) William Poole, Almon Hill, Senile Wills, Ansel Poole, and A.J. Fowler; (fourth row) Fred Rogers, Rembert Greene, and Tom Norrell. (Courtesy of Corinne Pace.)

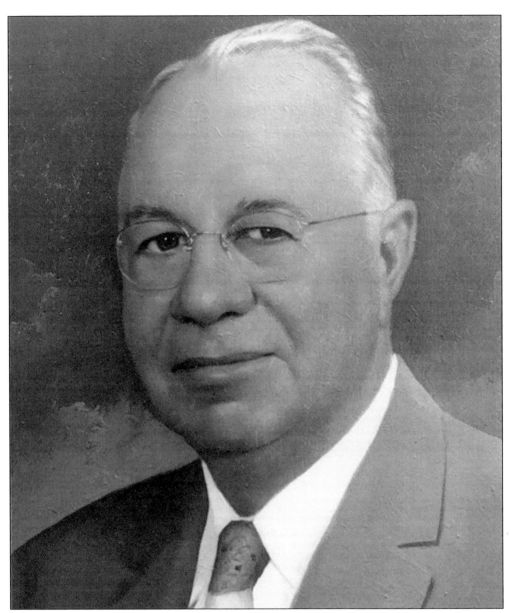

Dr. Marcus Mashburn Sr., born 1890, was one of Cumming's most esteemed citizens. In the medical field, he rendered caring service to those who sought his medical skills. His leadership in his chosen profession was evident when, in the mid-1940s, he converted the Mashburn Hotel on the square in Cumming to Mary Alice Hospital, a facility where babies could be born under more advantageous conditions than in the home. A decade later, he fought for a new Hill-Burton hospital in the county and, with the help of others, was successful in winning enough votes to enable the construction of the Forsyth County Hospital. In public life, Dr. Mashburn served as mayor of Cumming, as a member of the Georgia State Senate and House of Representatives, and as a member of the Forsyth County Board of Education. He and his first wife, Mary Katherine Summerour Mashburn, raised two sons, Dr. Marcus Mashburn Jr. and Dr. James Mashburn. After her death, he married Kate Rhodes. Dr. Mashburn died in 1978 and was buried in Cumming Cemetery.

Born in Forsyth County May 22, 1892, Judge John Harold Hawkins was the son of Perry C. and Della Bramblett Hawkins. He was admitted to the Georgia Bar in 1916, practiced law, and worked in the court system. From 1931 to 1948, he was judge of the Blue Ridge Circuit, and from 1949 to 1960, he was associate justice of the Georgia Supreme Court. Judge Hawkins died June 8, 1961. (Courtesy of the Garland Bagley Collection.)

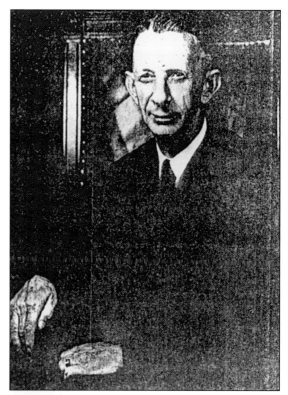

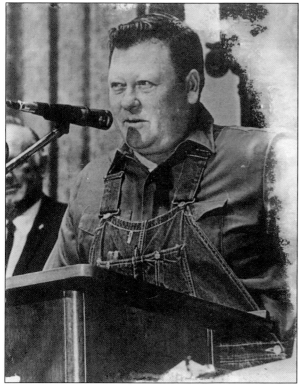

Entertainer of Hee-Haw fame, Junior Samples is pictured as he addressed the 1972 session of the Georgia Legislature. Born August 10, 1926, in Forsyth County, Samples was "discovered" when he found a dead fish in the road, spread a fish tale, and landed on television. Overalls were his trademark, and being himself endeared him to millions of viewers. (Courtesy of Garland Bagley Collection.)

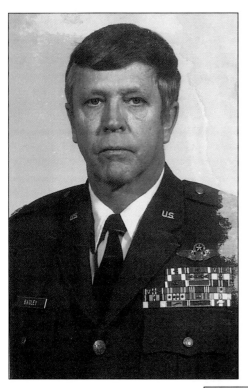

Col. Bobby Bagley epitomizes all the heroes from Forsyth County who sacrificed and suffered for their country. Born in 1933 in the Sharon community, Bagley entered the Air Force in 1953. Through a career in the service, he rose to the rank of colonel. His RF-101 was shot down over Vietnam in 1967, and he was held prisoner of war until 1973. (Courtesy of Garland Bagley Collection.)

Rev. Roy Bailey, born in 1924, is the son of Claude W. and Lizzie Belle Bannister Bailey. Ordained as a deacon at Concord Baptist Church, he was later called into full ministerial work in 1960. He joined the Order of Oddfellows at age 21, served in that organization's district and grand lodge offices, and was Grand Master of the State of Georgia in 1976-77. (Courtesy of Garland Bagley Collection.)

Born in 1918, Dr. Rupert Bramblett, a fifth generation Forsyth Countian, is the son of Dr. Rader Hugh Bramblett and the grandson of Dr. Martin T. Bramblett. He practiced medicine for 53 years, served as a leader in medical groups, and in civic life was a member of numerous boards and organizations, including the Masonic fraternity, in which he served as Grand Master of the State of Georgia in 1966.

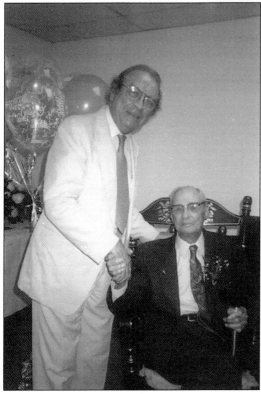

Dr. Rupert Bramblett (left) congratulates his friend, Arthur Sosebee, on the occasion of Sosebee's 100th birthday, celebrated with family and friends at Friendship Baptist Church in June 1991. An educator, Sosebee had encouraged a young Rupert Bramblett to continue his education. In later years, Sosebee became one of Dr. Bramblett's patients.

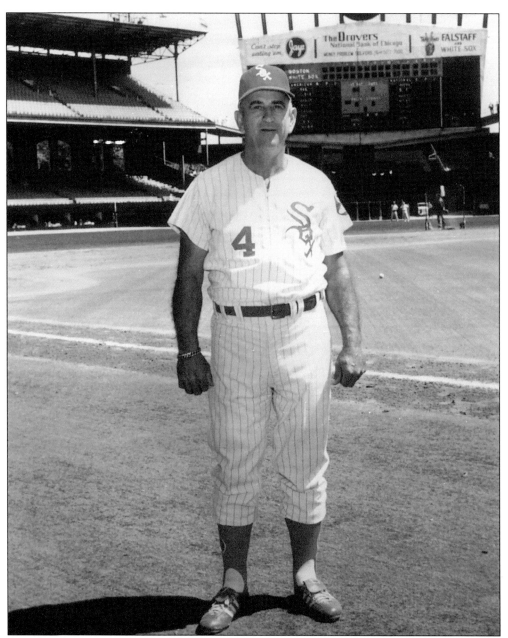

Noted individuals in a county include sports figures, and Luke Appling was a legend. Lucius Benjamin "Luke" Appling Jr. was born April 2, 1907 in High Point, NC, attended Fulton High School in Atlanta, and then spent two years at Oglethorpe University. His career in baseball began with the Atlanta Crackers in 1930; a few months later he moved on to the Chicago White Sox at a salary of $30,000 a year. His career spanned 20 years, and he twice garnered the American League batting title—in 1936 and again in 1943. Appling retired in 1950 with a batting average of .310. Following retirement as an active player, he remained in the game through coaching for 18 additional years. He is pictured here in an Old Timer's Game. Appling passed away January 3, 1991, at the age of 83 and was laid to rest in Sawnee View Memorial Gardens in Forsyth County. (Courtesy of Carol Appling Tribble.)

Six

VANISHING AND ALTERED STRUCTURES

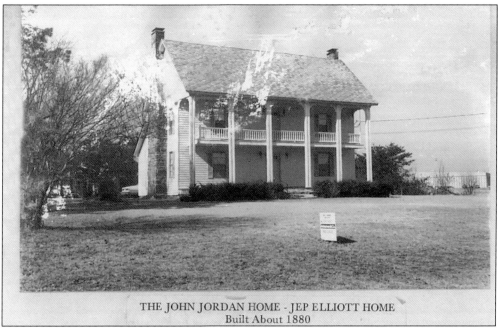

THE JOHN JORDAN HOME - JEP ELLIOTT HOME
Built About 1880

This house, constructed 1870-80, was known as the John Jordan Home and the Jep Elliott Home. It featured a central hallway, one room deep, with fieldstone chimneys within the roof surface, two verandahs, and a balcony. The fine old structure was last used as an antique shop before it was torn down by the department of transportation for a highway interchange, which was never built. (Courtesy of Garland Bagley Collection.)

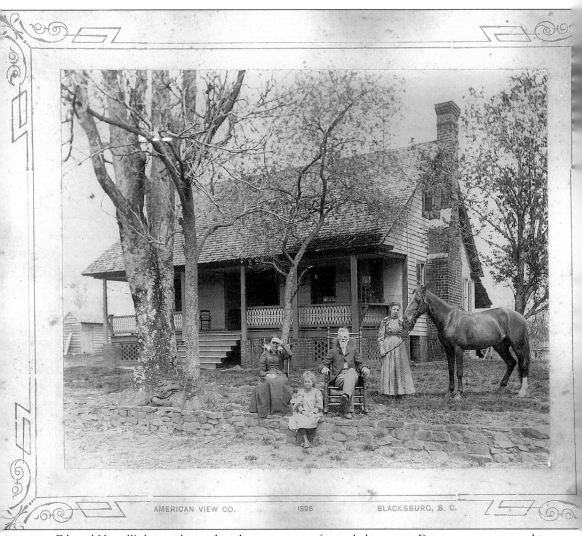

AMERICAN VIEW CO.　　　1896　　　BLACKSBURG, S. C.

Edward Harrell's house, located in the community formerly known as Drew, was constructed in the late 1830s by Harrell before his departure for the Gold Rush in California. Edward Harrell's son Newton also trekked to California, but the climate did not agree with his health, and he returned to the Forsyth County home. Newton Harrell and his wife, the former Mary Ellender Harris, raised a large family in this structure, which was located on the Post Road in western Forsyth County. With Newton Harrell as owner, the house appears to have been altered somewhat from pioneer times, as evidenced by the brick chimney and porch trim. Pictured here, from left to right, are Mary Ellender Harrell, grandchild Annie May Strickland, Newton Harrell, and daughter Fannie Harrell, holding the horse. The structure fell into disrepair when the last Harrell occupant, Miss Fannie Harrell, became unable to manage the property and entered a nursing home. Subsequently, it was razed and the materials used in a building in Cherokee County.

The Benjamin Perry Roper home in the Cuba settlement was located on the Cumming-Canton Highway before the road was paved and its direction altered in the mid-1940s. It was at his store building to the right of the house that Roper was fatally injured in a robbery in 1943. Currently situated at the corner of Hurt Bridge Road and Friendship Circle, the house remains in the Roper family.

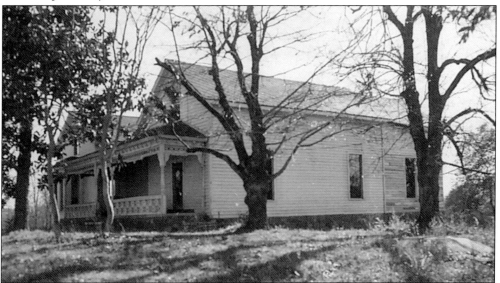

One of the oldest houses in Cumming, the home of Dr. Ansel Strickland, once boasted a windmill and picket fence in the yard, not to mention the physician's International Harvester, the second automobile in Cumming. In recent years, the structure was owned by Cumming mayor Ford Gravitt. Recently it has become the headquarters of the Cumming/Forsyth County Chamber of Commerce. (Courtesy of Garland Bagley Collection.)

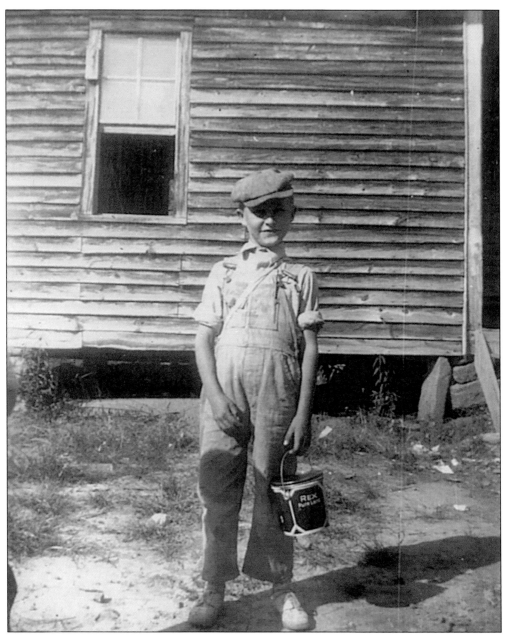

Hoyt Williams, shown in 1938 in front of the Hightower "Frogtown" School, typifies a schoolboy of the 1930s as he poses in overalls with a lard bucket (lunch) in hand. The principal, Spear Tallant, taught grades 5-7, while Ruth Hawkins Wallace instructed grades 1-4. Classes were held on the first floor of the building with the second story reserved for the Oddfellow Lodge. Pupils sat on long benches, because desks were scarce. The school offered few amenities: water had to be carried from the dwelling across the road, and a stick was used to prop the window when "air-conditioning" was desired. The discipline rule, "If he gets a whuppin' at school, he'll get a whuppin' at home," was generally carried out because brothers and sisters told on each other at home. Frogtown School was consolidated into Matt School before 1940 when bus transportation became available. (Courtesy of Ruth Hawkins Wallace.)

Frogtown Store, a short distance from the school, was located at the corner of State Route 369 and the Old Federal Road. It was the last in a series of country stores in the vicinity. In the early part of the century, the Heards had operated a store on the Old Federal Road behind the site of this building, which was closed and deteriorating badly by the early 1970s.

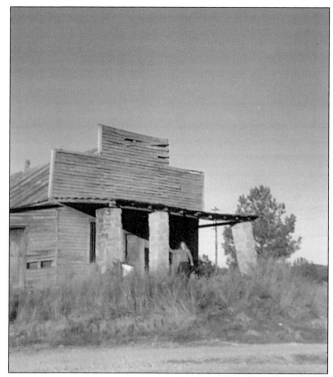

The old Bramblett home of Dr. Martin T. Bramblett, and birthplace of Dr. Rader Hugh Bramblett and Dr. Rupert H. Bramblett, was demolished when Dr. Rader H. Bramblett constructed a bungalow on the property just behind the site of the older structure. Dr. Rader H. Bramblett is pictured with his daughter Ruth as he prepares to begin a round of home visits.

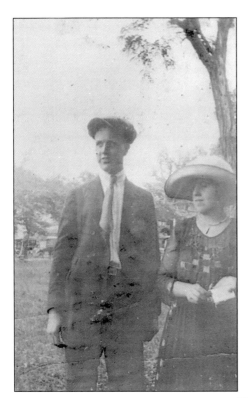

This duo, dressed to the nines, attended the June Singing held annually in the courthouse in Cumming. The singings ended in 1973, when the courthouse, constructed in 1905, was burned by arsonists. Although outdated and in need of renovation, the structure had served the county well and citizens grieved over its loss. It would be five years before another building was erected to take its place. (Courtesy of Joyce Hawkins.)

The June Singing, beginning in the 1920s, was the social event of the year. So large was the crowd that parking extended from the courthouse square to the Cumming Baptist Church. The church building, pictured here, still exists, with modifications, but is a part of a large complex, which includes a modern sanctuary, educational building, and family life center. (Courtesy of Joyce Hawkins.)

Chestatee School, completed in 1931 with funds derived half from the community and half from the county, was situated on 5 acres of land purchased for $275. Local residents literally rolled up their sleeves and raised the building by their own labor. The blueprint for the institution called for 14 classrooms, but only 10 were constructed originally. After months of toil, the building finally opened in November 1931. In 1939, Crossroads, Hopewell, and Pleasant Grove schools were consolidated into Chestatee, and the school's library was improved. Shortly thereafter, the school became accredited. The buses pictured here resulted from the planning of Penn Patterson, shown beside the center bus. Patterson was a blacksmith with an imagination, and devised a way to convert trucks into buses. By the end of the 20th century, both the buses and the school had changed considerably. The building is now a sprawling complex of brick and up-to-date classrooms for today's younger generation. (Courtesy of Virginia Paxton.)

Looks can be deceiving. The Chestatee School in this photograph is actually older than the one in the previous image. Its history dates to 1881, when Minnie Bailey Julian was in the early years of her teaching career. The members of Chestatee Masonic Lodge, F&AM, drew up an agreement with Abijah J. Julian, Minnie Bailey Julian's husband, to build a house 44 feet long, 22 feet wide, and two stories high. The upstairs was to be reserved as the Masonic Hall and the downstairs, the school area. The document was signed on September 9, 1879, by Matthew Cox, Worshipful Master; Lewis Keith, Senior Warden; and Thomas J. Brice, Junior Warden. The new building, erected two years later and known as the Julian School, served for years as both school and Masonic Lodge. At the end of the century, it still stands—restored as a dwelling and located on a bank overlooking Lake Lanier.

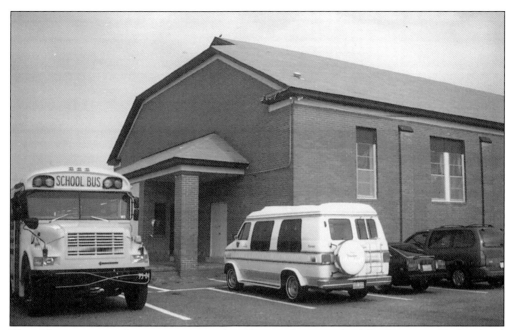

The old gym, as it was known, was erected in 1941 on the grounds of the Cumming High School at 101 School Street in Cumming on the site formerly occupied by the Piedmont College. Contractor Homer Byers minimized the structure's cost to the county by utilizing student assistance. Used for sports events, music recitals, proms, graduations, and various meetings for decades, the beloved facility was demolished in late summer of 1996.

Near the back of the old gym was a staircase rising to a two-story level. The second floor was occupied by LaFayette Masonic Lodge, F&AM. Here, regular meetings of the lodge were conducted until a time came when repairs were mandatory. The lodge opted instead for a land swap with the school system. A new lodge building was erected near the intersection of Elm Street and Canton Highway.

It's gone now. The old house first known as the Ervin Tatum home and later the Davenport and Kennemore house, has been replaced by a bank. Situated at the corner of Dahlonega and Church Streets, the rambling structure was demolished and replaced by Lanier Bank and Trust. The building remains intact, but it has gone through a series of owners, as have other banks in Cumming. (Courtesy of Garland Bagley Collection.)

The Hiram P. Bell Home With A Tree In Cedar Or Juniper Family Brought From The Botanical Gardens, Washington, D. C. When He Was Congressman

The Hiram Parks Bell house on the corner of Kelly Mill Road and Canton Highway was home to the noted writer, soldier, and statesman. Bell's earlier home had burned, and he moved into this structure in the declining years of his life. It was later occupied by Kirby and Ellene Kemp. In the 1980s, Ellene Kemp passed away and the house has since been utilized for business purposes.

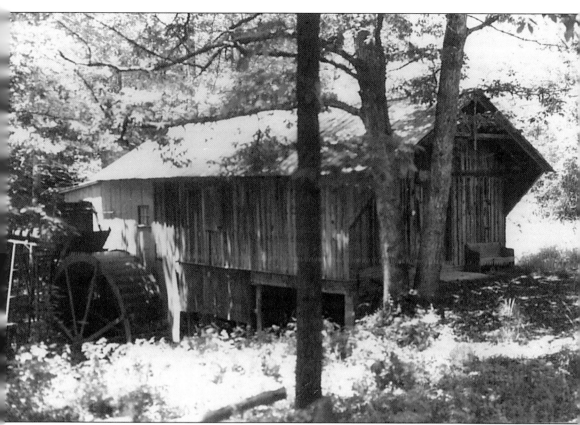

This photograph of the Dr. Marcus Mashburn Grist Mill was taken in the late 1970s or early 1980s. At that time the mill was still operable and was one of Forsyth County's last water-powered gristmills. A note by the late Garland Bagley indicates that Dr. Mashburn also ground grits and other corn products at the mill. Located on Sanders Road at Lake Alice—named for Dr. Mashburn's mother, Alice Kemp Mashburn—the grist mill was constructed on a stream on the Kemp farm, which passed down to the Mashburn family, and predates Lake Alice, which Dr. Mashburn built near mid-century. Dr. Mashburn completely renovated the mill in the early 1950s. Although not operable today, most of the mill's parts have been maintained in good condition. Because it is an example of a vanishing agricultural business, its uniqueness conveys historic value to both the mill works and structure that houses them. (Courtesy of Garland Bagley Collection.)

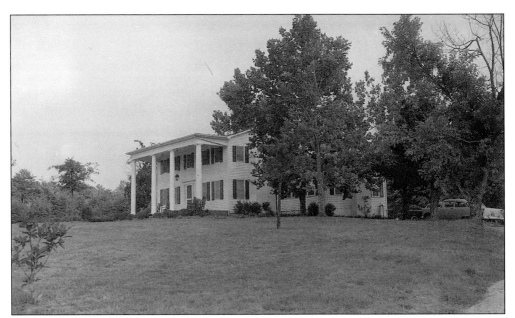

The stately home of the late Dr. Jim Mashburn was erected to replace an older structure that burned. The grounds, landscaped to enhance the beauty of the house, are dedicated to historic preservation, for Dr. Strickland's office, pioneer cabins, a covered bridge, spring house, and barbecue pit grace the area. "Dr. Jim," as he was known, was one of Forsyth County's most esteemed physicians. (Courtesy of Garland Bagley Collection.)

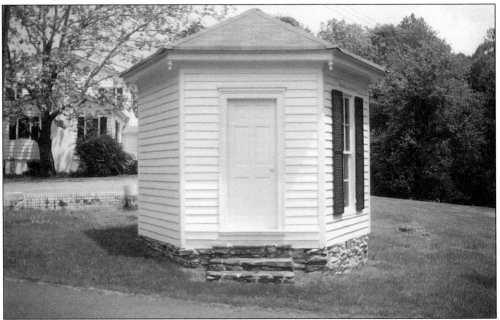

The doctor's office that once stood in the yard of Dr. Ansel Strickland when the 20th century was young now takes its place beside the driveway on the Dr. Jim Mashburn estate. However, the structure did not go directly from the Strickland yard to the Mashburn lawn—it stood for years on the grounds of the doctors' offices on Samaritan Drive where Dr. Jim and Dr. Marcus Mashburn Jr. practiced medicine.

Seven

CUMMING 1970–1980

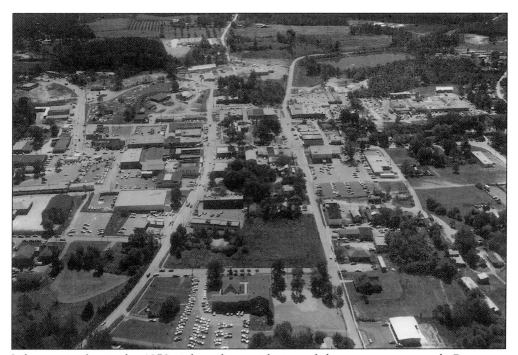

Life was simpler in the 1970s, when this aerial view of the town was snapped. Cumming, the seat of Forsyth County, was a somewhat laid-back town in a rural area. Stores closed on Wednesday afternoons and even government offices opened on Saturday mornings. Traffic was manageable on two-lane streets, and growth, while it occurred, was not astounding. (Courtesy of Garland Bagley Collection.)

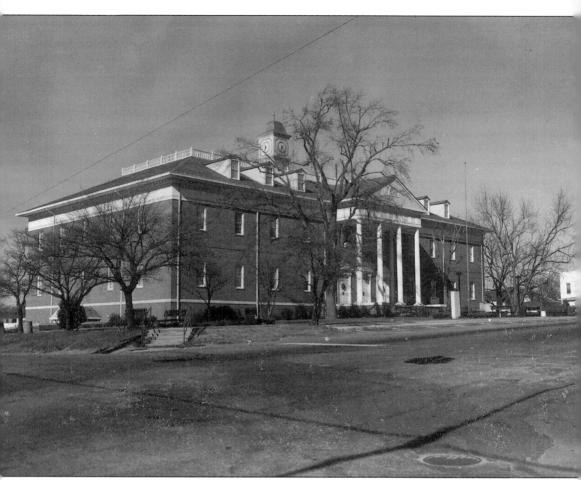

The courthouse that sits midpoint in the square was erected in 1978 after the shocking loss of the 1905 courthouse. When arsonists took the historic structure from the citizens, a wrangle ensued as to where the new courthouse should be constructed and of what style. Sites off the square were suggested, modern structures were designed, and voters defeated them every one. The Williamsburg-style courthouse that was finally approved—to sit in its proper spot on the square—was completed in the summer of 1978. Subsequently, it has been remodeled and offices shifted to accommodate an increasing demand for services. By 1996, the offices of the tax commissioner, the tag office, the department of planning and development, and the commissioners' offices and meeting room had been removed to a new building. Other changes are in the offing. (Courtesy of Garland Bagley Collection.)

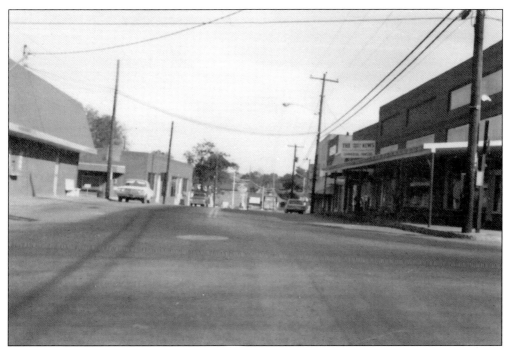

Standing on Old Buford Road and looking north from the square, one can view, on the right, Cumming Drug Store, for years operated by the Marcinkos. The *Forsyth County News* office and other businesses attracted customers to the block. On the corner at left, the Home Federal Savings and Loan occupied the building that for previous decades had been the Bank of Cumming. (Courtesy of Garland Bagley Collection.)

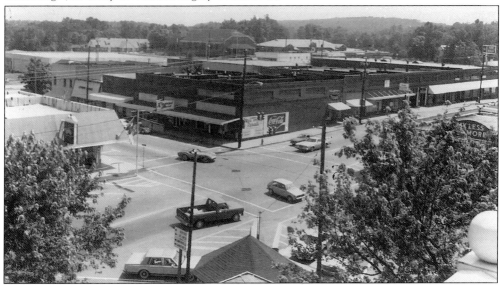

On the northeast quadrant of the square, Cumming Drug Store is centered with Otwell Motor Company to its right. Overlooking the tops of the buildings in the foreground, one can spot, from left to right, the Ingram Funeral Home, the old gym, and Cumming School in the background. During this era, the school changed from housing the upper elementary school to housing the offices of the board of education. (Courtesy of Garland Bagley Collection.)

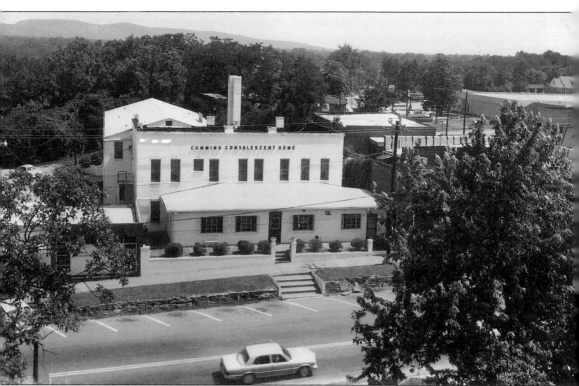

The Cumming Convalescent Home was a twice-converted building. Sitting at mid-point on the north side of the square, the facility was originally the Mashburn Hotel. When a fire destroyed the hotel and adjacent structures in the 1920s, J.W. Fleming rebuilt the hotel with bricks fired in his brickyard southwest of the square. Approximately 20 years later, Dr. Marcus Mashburn, realizing the need for a medical facility in Cumming, converted the hotel to Mary Alice Hospital where patients could receive more effective care than in the home. It was during the 1940s, too, when his sons, Dr. Jim Mashburn and Dr. Marcus Mashburn Jr., completed their internships and returned to join their father in his work at the hospital. Then in 1957, when the Forsyth County Hospital was erected, the building on the square was converted once more—to the Cumming Convalescent Home. The structure has been demolished in recent years. (Courtesy of Garland Bagley Collection.)

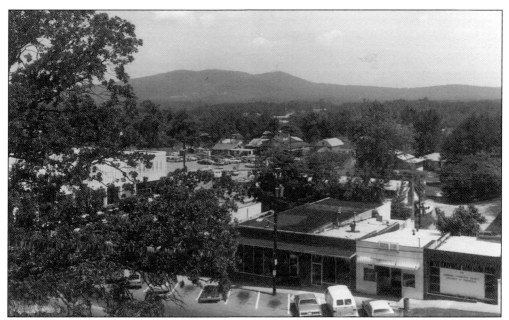

The northwest side of the square shows the Bank of Cumming and Ramey's Department Store. The bank began in a smaller building on the northeast corner of the square, then moved to the location pictured on left. Since the 1970s, the bank has experienced several mergers and undergone name changes as well. Ramey's has moved to a location on Canton Highway. (Courtesy of Garland Bagley Collection.)

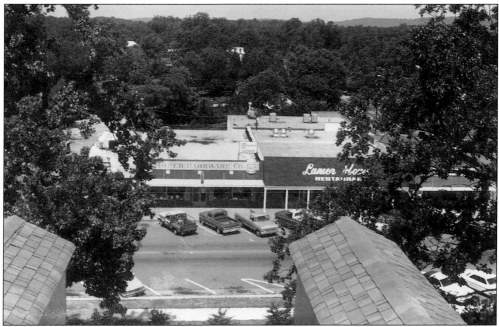

The west side of the square has likewise changed since the 1970s. Roper Hardware and Lanier House restaurant are no longer in business. Lanier House had replaced Gordon's Department Store in the early 1970s. The corner building on right, obscured by the tree, was Holbrook Hardware. It later became a pawnshop. (Courtesy of Garland Bagley Collection.)

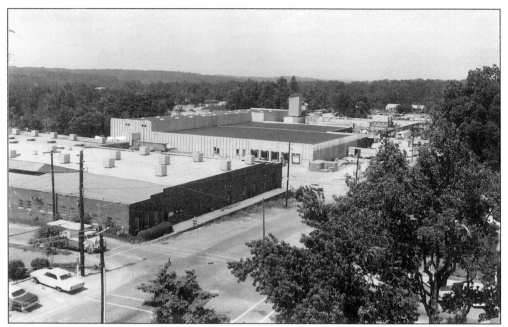

In this view of the southwest corner of the square, one sees the Russell Manufacturing Building and Tyson's Chicken Plant. The part of the Russell plant on the corner has become a parking lot, and Tyson's continues to process chickens. Tyson's took over the chicken plant, which was originally Wilson and Company. (Courtesy of Garland Bagley Collection.)

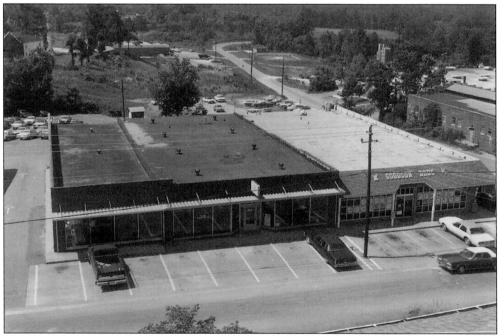

On the south side of the square, bordered by Castleberry Road and East Maple Street, are Goodson Drugs and Stone Furniture. Goodson moved to this location from a small store on the north side of the square. Stone Furniture remained in business until the end of the 20th century. (Courtesy of Garland Bagley Collection.)

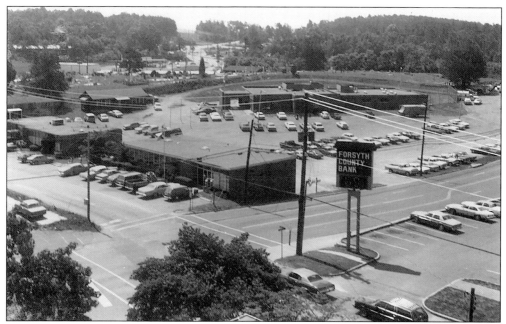

The southwest corner of the square, to the left of the view in the previous photograph, shows the Forsyth County Bank parking lot. The bank later became Wachovia. On the left is the county office building. In the background is the Forsyth County Jail with the Cumming City Cemetery appearing to be arced around it. (Courtesy of Garland Bagley Collection.)

The County Office Building is situated on the southeast corner of the square. It is bordered by Old Buford Road and East Maple Street. With the limited space available in the old courthouse, the addition of this building was essential to the functioning of the county government at the time of its construction. (Courtesy of Garland Bagley Collection.)

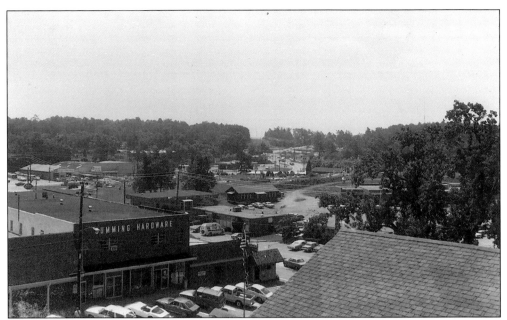

On Old Buford Road, near the corner of East Maple Street, Cumming Hardware was located on the east side of the square across from the main entrance to the courthouse. This business later moved to a new building on Old Buford Road near the fire station. Above the roof of the store in this picture is the small building that served as the library. (Courtesy of Garland Bagley Collection.)

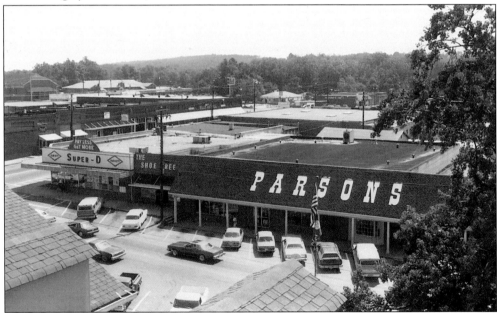

The east side of the square, north end, shows Super D, Shoe Tree, and Parsons. In earlier years, Parsons operated both a grocery and a dry goods section. Before the store was destroyed by fire in 1982, it had gone out of the grocery business and had enlarged its dry goods department. Subsequent to the blaze, Parsons relocated in Lakeland Plaza. (Courtesy of Garland Bagley Collection.)

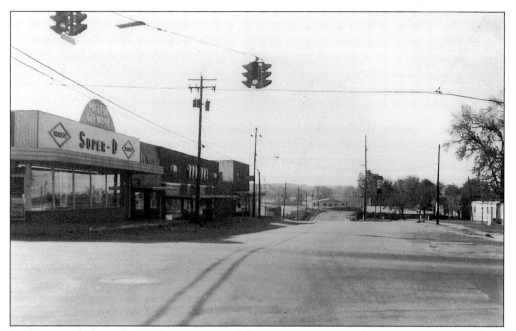

Looking south from the northeast corner of the square, Super D, Shoe Tree, Parsons, and the Jackson Building are visible on the left. The Super D Store was preceded by Fambro's. The courthouse is out of sight on the right. The building in the far distance at the road's curve is Cumming Hardware, which moved from the square. (Courtesy of Garland Bagley Collection.)

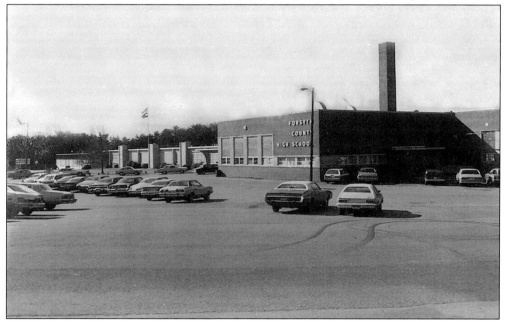

Forsyth County High School, opening in 1955, was the only high school in the county for approximately two decades. Students in grades 9-12 had previously attended classes in the Cumming School or at Chestatee. Chestatee High School was consolidated with Forsyth County High in the fall of 1967, and all students in the county began attending high school in one location. (Courtesy of Garland Bagley Collection.)

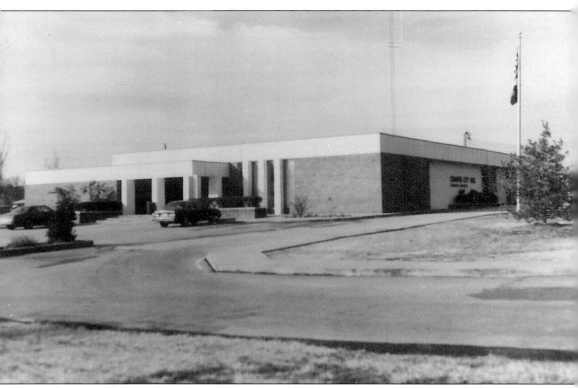

Cumming City Hall opened in 1974, after a fire destroyed the small building on the northeast corner of the square that had served as city hall for a number of years. City records were also destroyed, and the move into the building pictured was a new beginning. The 1974 structure, still in use, incorporates the offices of city government, the Cumming Police Department, and the Cumming Fire Station. In the main hallway are photographs of some of the mayors of Cumming: Henry Lowndes Patterson, John D. Black, A.B. Tollison, Dr. Marcus Mashburn Sr., Dr. Marcus Mashburn Jr., J.G. Puett, Roy P. Otwell, George Ingram, and Henry Ford Gravitt. A new city hall is planned for the north block of the square. The structure is to resemble the courthouse proposed in 1904 but scaled back for lack of funds. Thus, a dream lasting almost a century will at last become a reality. (Courtesy of Garland Bagley Collection.)

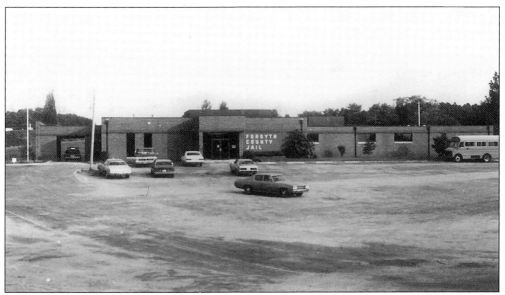

When the jail on West Maple Street had become obsolete, a new jail was erected in 1975-76. The modern facility served well for a few years, until overcrowding became a problem. An addition to the facility sufficed for awhile longer, and then additional offices were established in the magistrate building and in two precincts. The old library building was also utilized. (Courtesy of Garland Bagley Collection.)

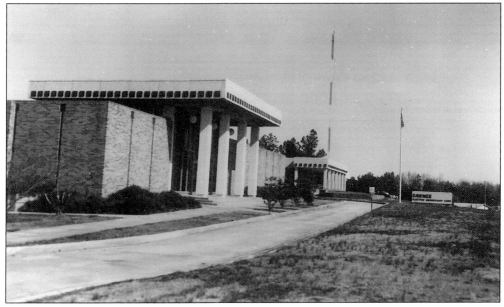

On June 22, 1939, citizens of four North Georgia counties gathered outside Cumming to celebrate the arrival of electric power. In a short time, 750 homes would be served with 168 miles of line and more miles awaiting construction. The Sawnee Electric Membership Corporation, its headquarters pictured here, is a cooperative, owned by its consumers, that continues to serve Forsyth County and surrounding areas. (Courtesy of Garland Bagley Collection.)

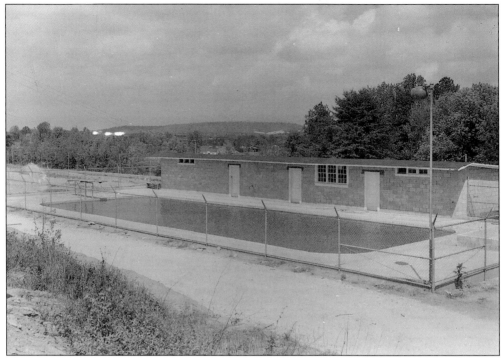

The Cumming Swimming Pool removed the need for the age-long tradition of damming a creek to form a swimming hole. This pool was a definite improvement over the former swimming area, which had rigidly enforced rules as to the separate times men and women could take a dip. With the increasing demand for recreational facilities, Cumming City Park would soon open a new, Olympic size pool. (Courtesy of Garland Bagley Collection.)

The Ingram Funeral Home has served Cumming and Forsyth County since 1928. Located on Ingram Avenue two blocks off the square, the facility had just undergone an expansion with the addition of a chapel for funeral services when this image was captured in 1978. The area to the left of the chapel would later be paved. (Courtesy of Garland Bagley Collection.)

Eight

PARADES

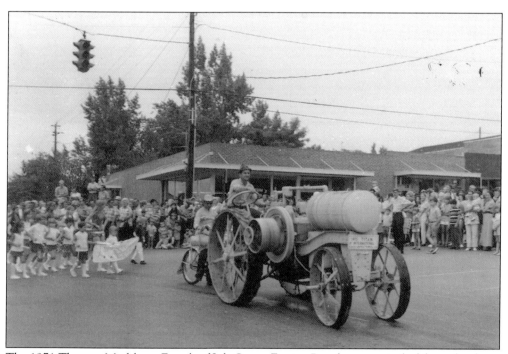

The 1971 Thomas-Mashburn Fourth of July Steam Engine Parade was typical of those that have been held for years in Cumming. Eager to celebrate Independence Day in a special way, citizens flock to the town square for an always entertaining event in which the traditions of old times are combined with the tradition of the unique parade itself. Forsyth County's heritage is on display. (Courtesy of the Garland Bagley Collection.)

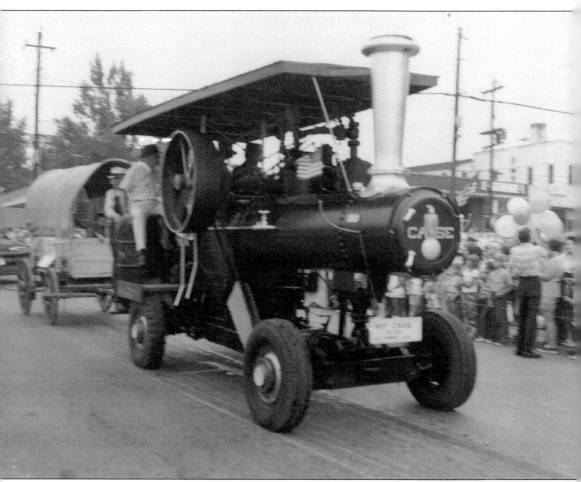

With the agricultural background of Forsyth County, combined with the people's love of excitement and the farmers' pride in showing off their engines, it is little wonder that a local engine owner, on impulse, decided to drive his steam engine around the square on the Fourth of July, 1958, according to the accounts of several citizens. Neither is it unusual that the townsfolk came out to help him celebrate. Cecil Merritt, however, is credited with organizing the first real parade, when, on July 4, 1962, A.G. "Glenn" Thomas, Roy Thomas, and Gene Bennett drove their engines around the square with five boys on bicycles following. Cecil Merritt, who had built radio station WSNE in 1961, set up a radio loop in the bandstand and broadcast the parade from that vantagepoint. Merritt continued to manage the parade for several years until he retired. (Courtesy of Garland Bagley Collection and Cecil Merritt.)

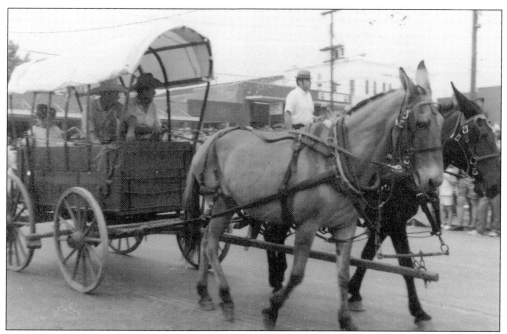

In 1971, the year most of the parade photographs in this chapter were snapped, steam engines remained the focus of the event, but other entries occupied a place as well. The people in this Conestoga wagon appear to have the same pride and determination as did their ancestors, who settled the area beginning in the 1830s. The mules, too, appear to be hardy specimens. (Courtesy of Garland Bagley Collection.)

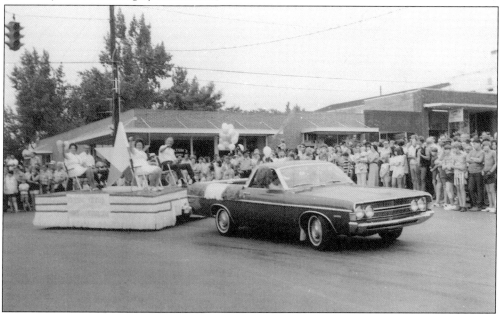

Floats have become increasingly popular in the Fourth of July parades. From nursing homes to political candidates to clubs and organizations, floats have been used to publicize each group's identity and to establish a presence in the festivities. From most of the floats, candy rains into the waiting crowd. (Courtesy of Garland Bagley Collection.)

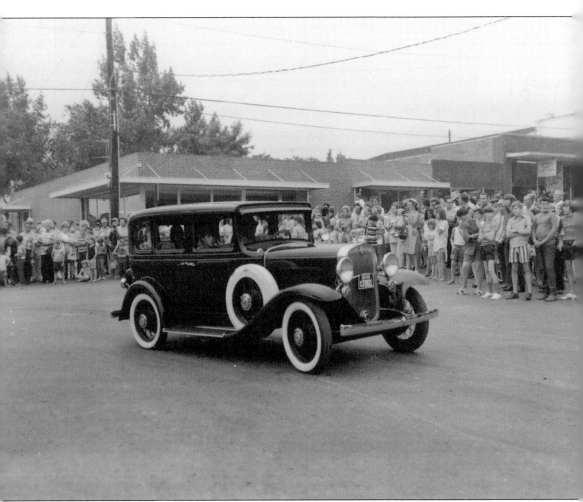

Antique cars, representing a bygone era, have their place in the parade, too. The drivers of these automobiles are equally as proud to participate as the farmer on the steam engine or the political candidate vying for public office. Indeed, what better way is there to show off a beautifully restored vintage automobile than to motor slowly through an admiring throng on Independence Day! Since displaying the older vehicles has become a favorite activity of car buffs, an entire parade section has been devoted to yesterday's autos driven by today's antique car enthusiasts. The car pictured here, as it passes through the northeast intersection of the square, is a fine relic of the past with its spare tire on the outside, running board, and whitewall tires. Its owner doubtlessly spent untold hours on its restoration. (Courtesy of Garland Bagley Collection.)

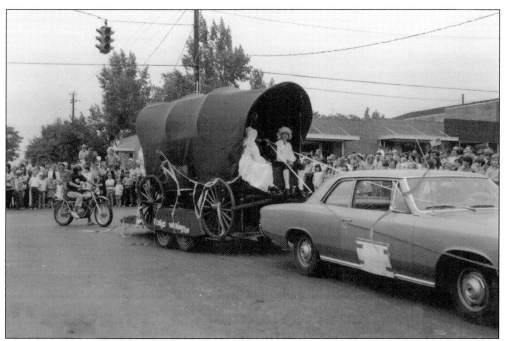

Another Conestoga wagon made its appearance. The previous one was drawn by mule power. This one, however, was pulled by horse power—but not of the equine variety. The participants were in period costume atop the front seat of a wagon carefully manipulated around the square on its flat bed trailer. (Courtesy of Garland Bagley Collection.)

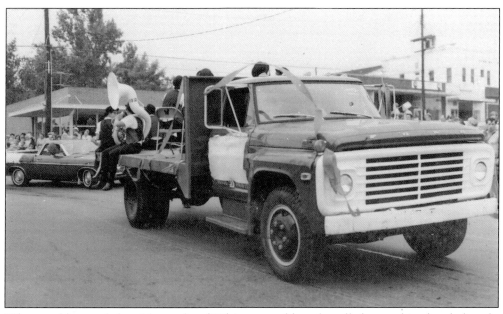

What would a parade be without a band? This one could not be called a marching band, though, for it took the easy route. From the bed of a Ford truck, the music sounded in celebration of our country's birthday with patriotic songs no doubt emanating from the vehicle. Perhaps those gathered were hearing "America the Beautiful." (Courtesy of Garland Bagley Collection.)

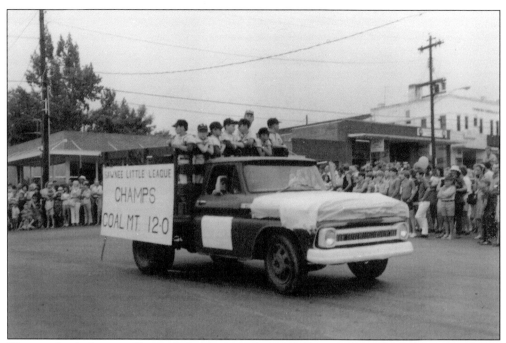

"Sawnee Little League Champs" the sign proclaims. Ball teams from throughout the county boasted of their skills in a parade that was for everyone, young and old alike. That students could participate contributed to the community spirit of the occasion. The parade could be said to be "for the people, and by the people." (Courtesy of Garland Bagley Collection.)

A youngster in a marching group would make any parent proud. As these little ones performed with their leader, the camera captured not only the children and their batons, but the north side of the square as well. Three decades later, this same block would be demolished in preparation for the construction of a new city hall. (Courtesy of Garland Bagley Collection.)

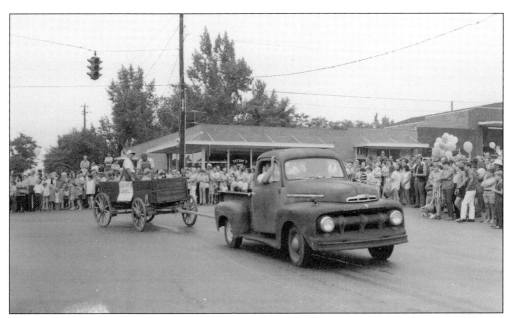

The truck and wagon have just passed Tatum's Store on the corner of Main Street and Bettis-Tribble Gap Road. Wagons, such as this one, may not convey the same sense of adventure as the Conestoga wagon, but they were employed extensively on the farm in hauling crops, wood, and other necessities, not to mention their use in transporting the farm family. (Courtesy of Garland Bagley Collection.)

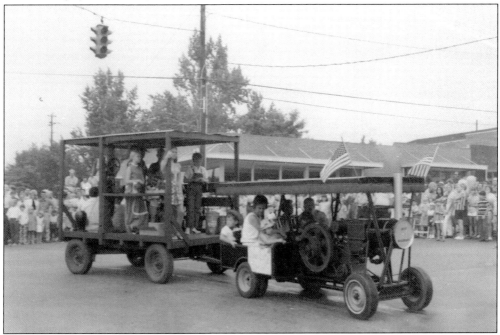

There were the large steam engines, such as those used in wheat threshing, and then there were smaller engines as well. This one appears custom-made for the people it is transporting. The group continues on an extension hitched behind. If another conveyance were to be added, would the entire entry be called a train? (Courtesy of Garland Bagley Collection.)

The equine unit has traditionally been placed at the rear of the parade. Some may think this is not fair. However, they should think again. Separating horses and steam engines is a common sense thing to do. No one would want the deafening blast of one of the mighty whistles to startle a skittish mount, especially near plate glass windows and scores of onlookers. (Courtesy of Garland Bagley Collection.)

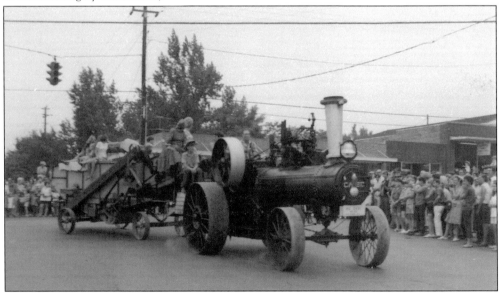

The attachment on this steam engine offered its riders a high perch and a bird's-eye view of Cumming. Intent on the activities of the day, these participants likely circled the courthouse square with no thought whatsoever that the historic courthouse in its center would soon be gone—in two short years. And as time passed, the buildings in the background would likewise be removed. (Courtesy of Garland Bagley Collection.)

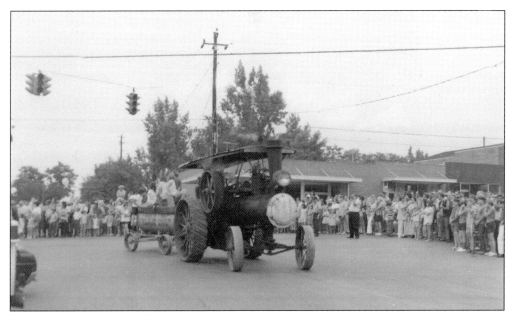

Forsyth County's love affair with the steam engine dictates that the viewer should have one more look. This engine, purposely misplaced here, provides a final inspection of a machine that has given the Thomas-Mashburn Steam Engine Parade its statewide claim to fame—with concomitant media coverage. It was a grand spectacle in 1971. (Courtesy of Garland Bagley Collection.)

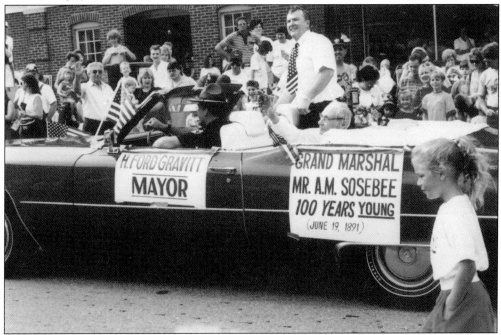

Two decades after the 1971 parade, Arthur Sosebee served as grand marshal of the parade and rode in the convertible with Cumming mayor H. Ford Gravitt. Shortly before the Steam Engine Parade, Sosebee had celebrated his 100th birthday—on June 19, 1991. Incidentally, Arthur Sosebee passed away in his 102nd year. (Courtesy of Edith Wright.)

This parade wasn't on the Fourth of July and it had no steam engines. Runner Jim Rice, followed by his entourage, carried the flame for the XXIII Olympiad through Cumming on May 31, 1984, at about 1:30 p.m. The flame had come from Greece and was kept alive as it made its way to Los Angaeles. Rice is pictured here passing in front of the Forsyth County Bank. (Courtesy of Garland Bagley Collection.)

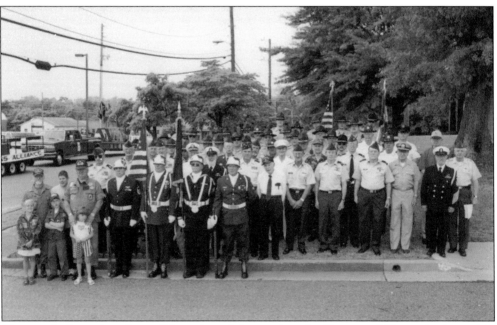

Composed of members from all branches of the service, the Veterans Alliance is pictured in 1999 in its first parade in Cumming. With chartered sponsors, the organization charges no dues and holds no meetings except for the Honor Guard. Its purpose is to memorialize veterans who have died, to recognize veterans of the area, and to educate youth on the contributions of the armed services. (Courtesy of City of Cumming.)

Nine

PRESENT-DAY CUMMING

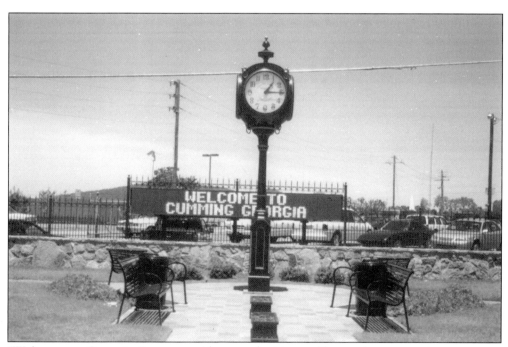

"Welcome to Cumming" greets residents and visitors alike as they motor into town on Highway 9. The mini-park at the junction of Highway 9, Pilgrim Mill Road, and Pirkle Ferry Road is one of the latest beautification projects of the city. It follows the town's theme of upgrading the appearance of Cumming with a historical flair that indicates the townsfolk care about their past.

The lampposts around the town square and cemetery seem to be lighting the way to the future while focusing on the past. The city's banner cum logo, modern traffic signal, and the lamppost are a compatible blend of the old ways with the new. With the best of both worlds in evidence, the appearance of the town offers a feeling of permanence and optimism.

Around the square and cemetery and projecting down some of the side streets, the wrought iron fence is a return to old Cumming, when the 1905 courthouse graced the center of the square, and around its periphery a similar fence ringed the historic structure. This view of Main Street depicts the site of the Cumming Convalescent Home and businesses now demolished on the north side of the town square.

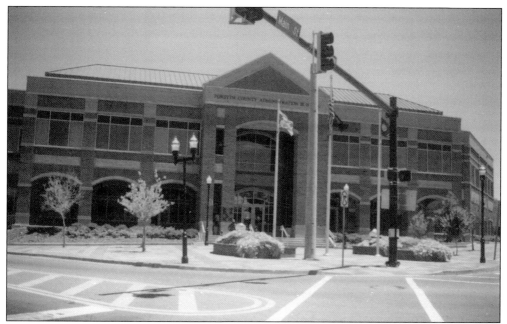

Constructed diagonally on the corner of Main and Dahlonega Streets, the Forsyth County Administration Building overlooks the square. As the 1978 courthouse became impossibly overcrowded, the need to expand office space was addressed in 1996 with the erection of this handsome structure, which currently houses the tax and tag offices, the department of planning and development, the commissioners quarters, and other functions of county government.

This image of the interior of the Forsyth County Administration Building, taken from the balcony at the entrance to the commissioners' office, shows a view of the lobby from the second floor. To the left of the front door, as seen here, is the office of planning and development. Immediately outside the entrance is a statue commemorating the chicken industry.

Across the street from the Forsyth County Administration Building sat the structure that years ago was the Bank of Cumming. A highly successful enterprise, the Bank of Cumming moved from this location to a larger building at the opposite end of the square. For years afterward, this structure, which has been razed now, housed the Home Federal Savings and Loan Association and later various other businesses.

Vittles on the Square, the north quadrant, has served its last meal. So, too, have the offices and businesses in this photograph transacted their last sales. From the roadway in the foreground through the parking lot behind, the buildings here have been cleared away for a new city hall building to resemble a courthouse originally planned in 1904. Bettis-Tribble Gap Road, running diagonally, is slated for a widening project.

On West Courthouse Square, Happy Family Restaurant replaced Lanier House Restaurant from an earlier photograph, and the Cumming Pawn Shop occupies the building formerly known as Holbrook Hardware. The white building on the far right was the Bank of Cumming for years, but with several mergers, the name has changed as frequently as the bank stock.

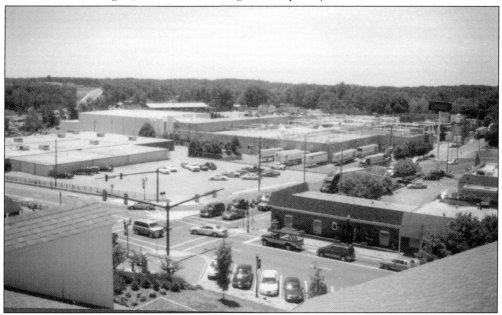

On the southwest quadrant of the square something is missing—the old Russell Manufacturing building. A parking lot now occupies the corner at East Maple Street and Castleberry Road. In the exact center of the picture may be seen Tyson's. The chicken plant has expanded its facilities and employs a large number of workers from Forsyth and surrounding counties.

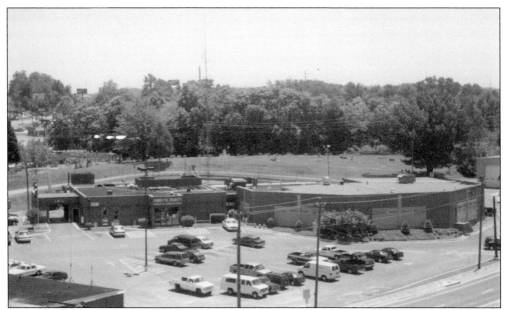

The Forsyth County Detention Center has undergone an expansion since its construction in the 1970s. The picture is deceiving, however. The sheriff's office has acquired office space in several buildings around the square and established precincts in other locations. With the increased need for police services has come an expansion of the sheriff's force, as well as an increase in the number of patrol cars, technical support, and equipment.

The parking deck, built to relieve the need for increased parking spaces in the downtown area, serves both the Forsyth County Courthouse and the Forsyth County Administration Building, as well as nearby businesses and professional offices. Motorists may access the deck from Main Street, East Maple, or the alley behind the Dairy Queen. Parking is free, and all day parking is acceptable.

Cumming City Park on Pilgrim Mill Road is home to ball fields, a picnic area, swimming pool, and tennis courts. This view of the park shows both the tennis courts and the swimming pool. Directly across the street in the old Methodist church, park offices are maintained and limited facilities are available for other activities.

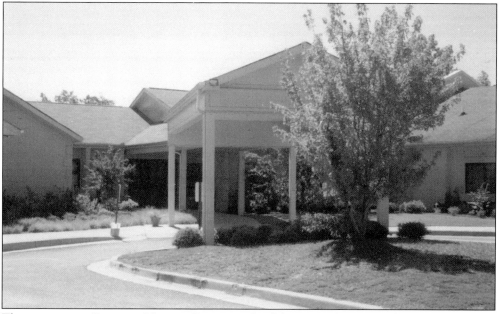

The entrance to Cumming Nursing Center on Castleberry Road is pictured here. This modern building replaced the old Cumming Convalescent Home, now demolished, on the town square. (The Convalescent Home was formerly the Mashburn Hotel and the Mary Alice Hospital.) Adjacent to the nursing center is the Cumming Manor, an assisted care facility.

With the influx of residents that Cumming and Forsyth County have experienced in recent years, the need for apartments has become manifest. The upscale apartments under construction here were approved by the city as a viable solution to the housing shortage. Other apartments on Hutchinson and Castleberry Roads have also attempted to address this need.

Subdivisions within the city limits of Cumming are not as prevalent as in the outlying areas. Nevertheless, well-planned developments do exist. The subdivision in the photograph, which is on Hutchinson Road in Cumming, features fine houses with minuscule yards that require minimal upkeep. Others subdivisions will likely follow as the area's population continues to rise.

The Andean Motor Company, established in 1948 by James Otwell Jr., was named for his two daughters, Patricia Ann and Sarah Dean. The Chevrolet dealership, first located on Highway 9 across from the city cemetery, moved to its present location farther south on Highway 9 in late 1970. It was operated by the late Donald Creamer and Jim Otwell.

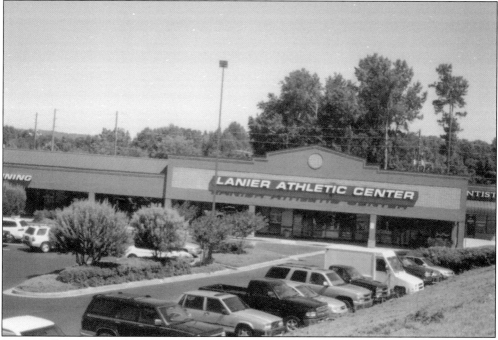

Lanier Village was the first shopping center to be located in Cumming. Its anchor stores were Ben Franklin, Food Giant, and a theater run by Ivan Orr. Today the center has undergone a facelift, expansion, and a name change to Lanier Crossing. Its anchor businesses include Lanier Athletic Center at the old Ben Franklin site and Hobby Lobby.

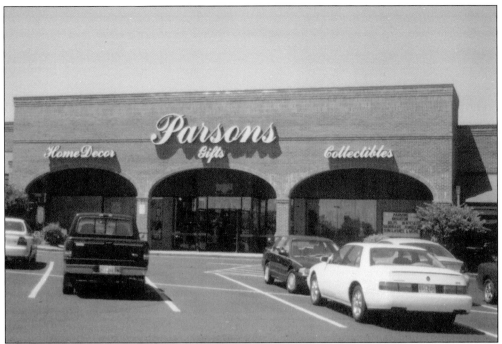

Parsons began with a store on the square in Cumming. For years, it sold both dry goods and groceries. Before the fire that destroyed the building in 1982, it had eliminated the grocery section and expanded its dry goods offerings. Subsequent to the fire, Parsons has been located in Lakeland Plaza. As the picture indicates, it specializes in home decor, gifts, and collectibles.

If two factors responsible for the rapid growth of Forsyth County had to be named, Lake Lanier and Georgia 400, pictured here, would be credited. Highway 400 connects Cumming and Forsyth County with the Metropolitan Atlanta area to the south and Dahlonega to the north. Constructed in stages in the 1970s, the limited access highway has transported the population northward by the tens of thousands.

Since 1992, the Forsyth County Public Library has served its patrons well, so well in fact that a new branch—Sharon Forks—was demanded for the southern area of the county. The main branch, pictured here, first began as a part of the Gwinnett-Forsyth library system, but in recent years, it has become self-contained. The library offers multiple services and features a research area and meeting room.

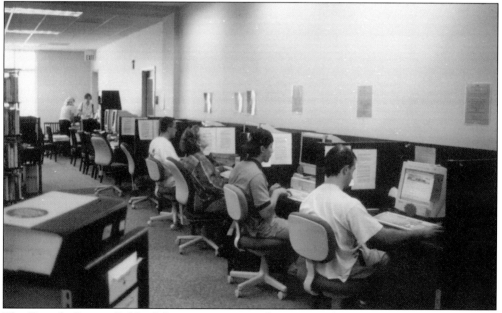

The Forsyth County Public Library, in its research section, offers internet access through its computers, as evidenced in this photograph. Also available are microfilm readers for those who wish to delve into the county's history. Long range plans call for expansion of the facility to provide even more services for library patrons.

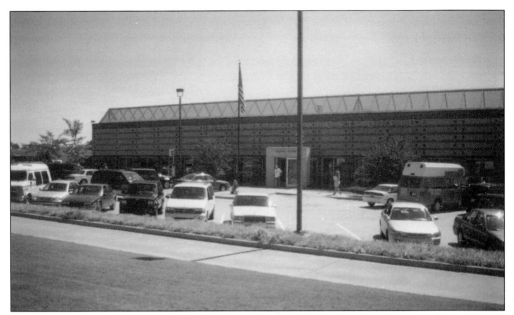

The U.S. Post Office in Cumming is located on Tribble Gap Road across from Forsyth Central High School. In the late 1960s, it occupied a building on Pirkle Ferry Road near the intersection of Highway 9. Outgrowing that site, it moved into a new building on Canton Highway. When the Canton Highway location became woefully inadequate, it moved to its present location in 1992.

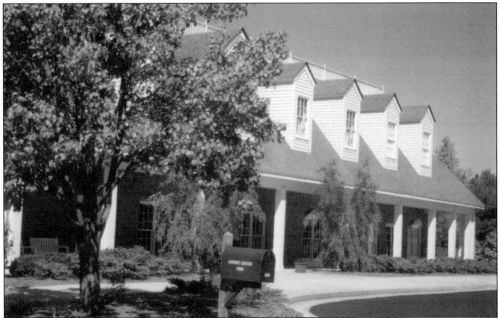

The Sawnee Center was erected to meet the cultural needs of the community. Following its grand opening on February 29, 1992, the facility has been the site of theater productions, meetings, dinners, wedding receptions, community fund raisers, political forums, dances, quilting exhibitions, and other uses too numerous to mention. Space allows for several activities to be scheduled simultaneously.

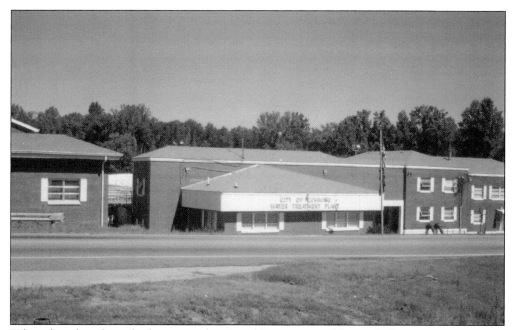

When droughts plagued other areas, the city of Cumming could provide for its water customers through the use of this up-to-date water treatment plant on Dahlonega Highway. With the plant on-line, taps were flowing throughout the city and the unincorporated areas that it serves. Lake Lanier is the source of water for Cumming/Forsyth County.

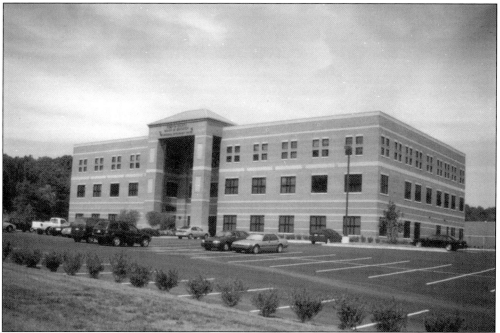

In the fall of 1999, the Forsyth County Board of Education moved its administrative offices from the old Cumming School building on School Street to a new state-of the-art building on Dahlonega Highway. Features of the new structure include not only the county offices, but the Betty Benson Room for instruction of teachers and meeting facilities as well.

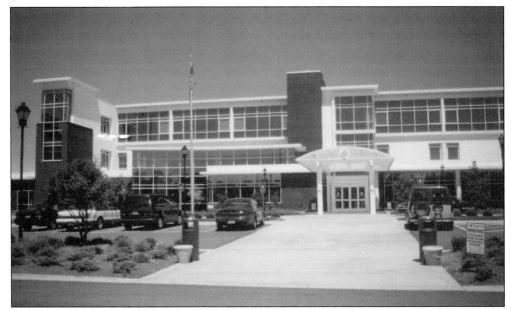

The grand opening celebration and ribbon cutting ceremony for the Baptist Medical Center, a part of The Georgia Baptist Health Care System, was held March 12, 1999, after Georgia Baptist relocated from the Samaritan Drive building that was originally Forsyth County Hospital. The modern facility is accessed from Highway 20 east and is situated adjacent to Highway 400.

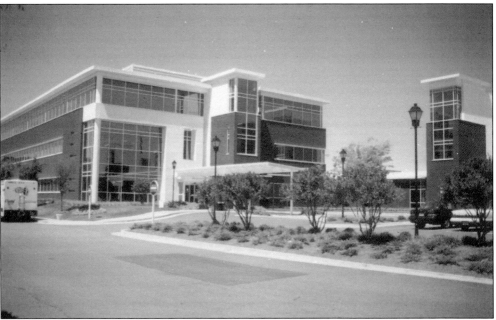

Beside the Baptist Medical Center, the new doctors' building houses offices for some of the physicians who serve the hospital. Medical care in Cumming and Forsyth County has made unbelievable strides during the 20th century—from treatment of patients in the homes, to the Mary Alice Hospital on the square, to the Forsyth County Hospital constructed in 1957, to facilities connected with Georgia Baptist at the end of the century.

Ten

REMEMBERING THE PAST

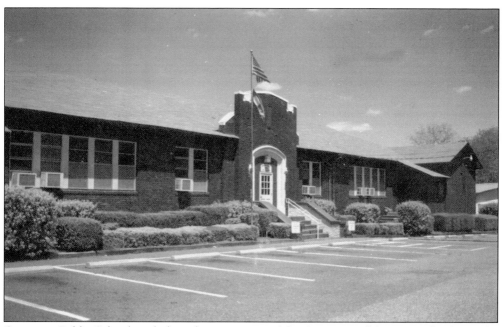

Cumming Public School symbolizes the aspirations of the Cumming of the past and its hopes for the future. Erected in 1923, the building burned and was rebuilt in 1927. It first served grades 1-11, then grades 1-8, and finally grades 7-8, before it was converted to the offices of the board of education. The school has recently been placed on the National Register of Historic Places.

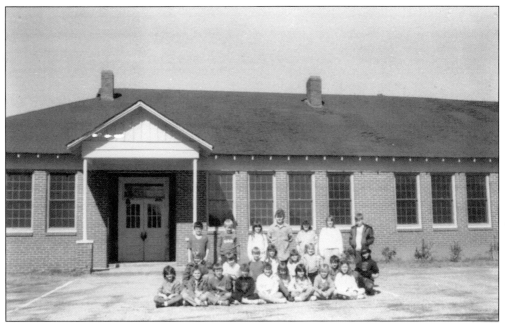

The way to preserve a knowledge of the past is by passing it on to the younger generations. These third graders visited the old Friendship School, which opened in 1948 and closed in 1968. The land, donated provisionally by Frank Roper, reverted back to him when Friendship consolidated with Sawnee Elementary in 1968. Ironically, the county had just finished paying the 20-year bond for construction of the school building.

Again, the third graders visit a historic site—the gold mine on Sawnee Mountain. At the beginning of the 20th century, considerable prospecting was conducted on the mountain and some gold recovered. The expenditure of funds necessary for obtaining the gold, however, precluded mining as a profitable enterprise. Currently efforts are in progress to preserve some of the Sawnee Mountain property as public land.

Poole's Mill Covered Bridge, built in 1901, has held a special place in the hearts of Forsyth Countians for generations. The bridge was placed on the National Register of Historic Places in 1975. In 1999, the Historical Society of Forsyth County opted to seek a Historical Marker for the structure. Pictured here is the Poole's Mill Bridge Historical Marker before it was removed from its shipping crate.

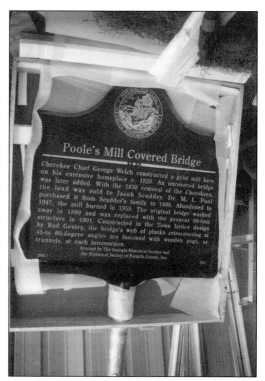

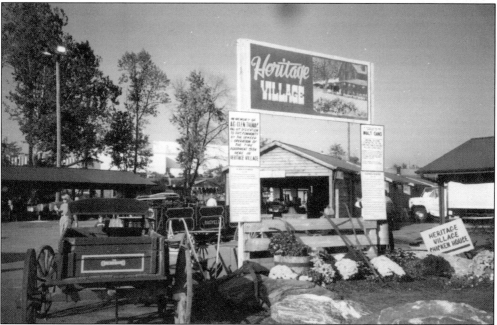

Mayor Ford Gravitt and the Cumming City Council sought a way to preserve the heritage of Forsyth County. Heritage Village in the Cumming Fairgrounds is a living exhibit of the way things were in the "olden days." The village features a series of functional shops: blacksmith, grist mill, post office, general store, doctor's office, barber shop, churches, and school—to depict life of yesteryear.

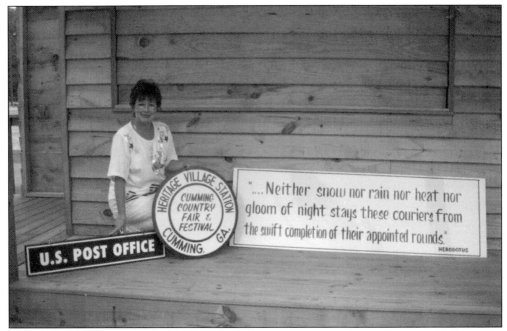

Hometown coordinator Linda Heard poses in front of the post office in Heritage Village. The postman's motto and cancellation stamp for the village are shown here before they were affixed to the building. During the time of the fair each October, post office workers stamp outgoing mail and sell postcards of historic sites in the county.

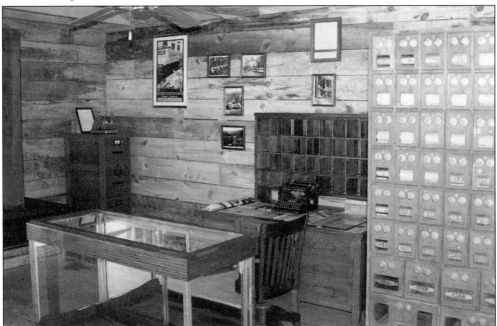

The interior of the post office is a step back in time. With its pigeon hole furniture, post office boxes, manual typewriter, and writing desk, an antiquated mailing system is brought back. One will not find computer-sorted mail here, nor modern trucks for delivery. The only clue that this is only a replica is the price of the stamps.

Fair-goers need only to visit the blacksmith shop to dispel the myth that blacksmiths only shoe horses. Blacksmiths, or farriers as they are called, do shoe horses, but their skills far exceed their tasks with equines. The blacksmith of yore made tools for the farm and fashioned hardware for the home. Metal was heated, then pounded into shape, and cooled in a water bucket.

The Historical Society of Forsyth County participates in the fair each year by displaying photographs of people and places of the past and by selling items promoting the history of the area. In this picture, from left to right, historical society members Cathy Fears, the late Harold Heard, and Brenda Heard are offering Gladyse Barrett's *Stroll around the Square in Cumming* and calendars of historic churches for sale in the gazebo.

To say that Heritage Village is a masterwork in its portrayal of the county's history would be an understatement. Even the walls in the restrooms are a reminder of the way things used to be. In this mural by Rick Rennick, the role chickens played in saving the area from economic disaster is readily apparent. The Wilson and Company processing plant blends into the background scenery.

Standing at the front steps of the Forsyth County Administration Building, this sculpture by Greg Johnson, dedicated 1997, reminds all who pass through Cumming of the importance of chickens to the area. The likeness of Rev. Ford Phillips, on the right, represents all the chicken farmers of the area, while the young girl stands for all the children who enjoyed the improved standard of living created by the chicken industry.

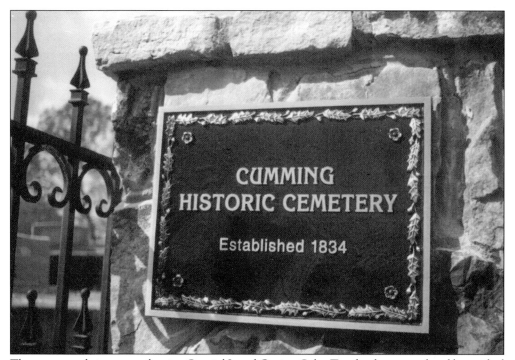

The mayor and city council, using Special Local Option Sales Tax funds, restored and beautified Cumming City Cemetery. In addition to righting stones and indicating gravesites, the work included the installation of lampposts and a wrought-iron fence atop a new rock wall. The dedication honoring those interred in the cemetery and establishing the name Cumming Historic Cemetery was held on November 11, 1999.

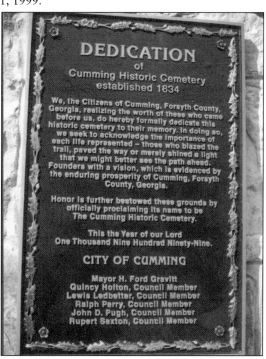

Cumming Historic Cemetery was the burial site for the citizens of the town from the year 1834. Hiram Parks Bell, Dr. Ansel Strickland, Dr. John Hockenhull, Michael Hutchins, soldiers of all wars, merchants, ministers, mothers, and babies are some of those interred within its walls. Two early churches existed on the cemetery's periphery, but were later moved elsewhere, and the graveyard quickly became a municipal burying ground.

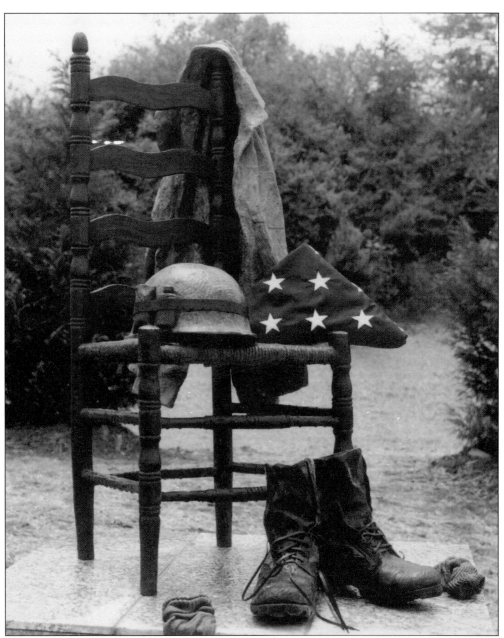

The War Memorial on the grounds of Cumming City Hall was dedicated on May 21, 1992, with these words from the Veterans' War Memorial Committee, as published in *The Forum*: "Realizing anew the full portion of sacrifice paid by the sons and daughters of Cumming, Forsyth County, Georgia, in defense of life and individual rights, we, the citizens, in gratitude and honor, dedicate this monument to their memory. And in doing so, pledge to preserve and protect the freedoms for which they so bravely fought. This place will be held in reverence for all those who wish to pause and remember how we came to live in this sweet land of liberty. America, America, God shed His grace on thee!" Since the dedication in 1992, commemorative services have been held at the memorial on Memorial Day, Confederate Memorial Day, and Veterans Day each year.

The Vietnam Moving Wall, a scaled-down replica of the wall in Washington, D.C., arrived in Cumming and was set up on the grounds of the War Memorial in front of city hall for viewing by area residents and visitors on May 3-9, 1998. Opening ceremonies on May 3 emphasized the theme "For those who fought for it, freedom has a flavor the protected will never know."

A special parade and festivities in the barn at the Cumming Fairgrounds were held in November 1999 to usher in the year 2000. City officials, who have labored diligently to preserve the history of Cumming and Forsyth County, dressed in period attire. Pictured, from left to right, are Rupert Sexton, Lewis Ledbetter, John D. Pugh, Mayor Ford Gravitt, Ralph Perry, and Quincy Holton.

The link between the past and the future is our children. Here, Emily Payne poses with the lantern of her great-great-great-grandfather, Dr. Martin T. Bramblett, who attached the light to his buggy as he drove his team of horses, Meg and Mag, through the night to minister to the sick. Emily's great-great-grandfather, Rader Hugh Bramblett, and her great-grandfather, Rupert H. Bramblett, themselves became physicians, who, in the tradition of the country doctor, also made house calls—although not in a horse-drawn buggy. But be it in medicine or whatever walk of life the individual of today may find himself or herself, it is hoped that the lantern and the spirit it represents will be a guide to the future with the firm, unwavering resolve passed down by the courage of our ancestors in Forsyth County, GA.